type INMOTION

innovations in **digital** graphics

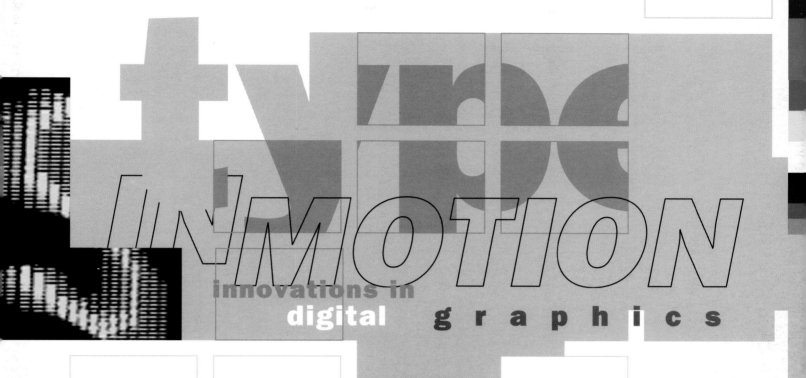

type
inMOTION

innovations in
digital graphics

Jeff Bellantoni and Matt Woolman

RIZZOLI
NEW YORK

CONTENTS

For Kimberly.
And for my family, Mom, David, Melissa, James, Bryan, Rebecca and Carmen.

Jeff Bellantoni

For Ursula.

Matt Woolman

First published in the United States of America in 1999 by Rizzoli International Publications, Inc. 300 Park Avenue South, New York, NY 10010

First published in Great Britain in 1999 by Thames and Hudson Ltd, London

© 1999 Jeff Bellantoni and Matt Woolman

All Rights Reserved. No part of this book may be reproduced in any manner whatsoever without permission in writing from Rizzoli International Publications, Inc.

ISBN 0-8478-2184-6
LC 98-75138

Printed and bound in Hong Kong

TIME-BASED MEDIA

Our ability to communicate with one another is dependent on the effectiveness of the available recording and delivery system. Before ideas and thoughts were painted on walls, carved into stone, written or printed on paper, ancient poets used delivery techniques known as mimesis and diegesis to communicate their thoughts and ideas. Mimesis is a literal, or direct, form of story-telling and diegesis is a more figurative, or indirect, delivery of a narrative. Singing, acting, and storytelling were the only methods of communication and expression. The aural qualities of the human voice and the formal qualities of body gestures collectively served as a real-time media delivery system. The original recording device consists of the eyes, ears, and brain. Processing and organizing oral discourse requires active thought and memory as words and images are not visibly anchored to a surface within a visibly defined structure or framework.

Pictograms and ideograms—visual markings that represent ideas and thoughts—were used in the first attempts at recording information for what can be termed time-*independent* communication. The modern Western alphabet evolved in this manner as a simple, modular symbol system through which thoughts and ideas could be externalized and fixed onto a flat surface by the human hand. But this system had to be learned, and many people did not have the resources, training or opportunity to benefit from this powerful communication tool until the 15th century when the German goldsmith Johannes Gutenberg began producing 42-line Bibles and other printed matter using his moveable type press. Gutenberg translated handwritten and calligraphic letterforms found in medieval illuminated manuscripts into simplified typographic characters cast as physical, three-dimensional objects that could be used and re-used to print multiple copies of the same text efficiently and expediently.

The packaging and distribution of portable texts in the form of the printed and bound book allowed ideas, information and *knowledge* to enter the vast arena of public consciousness. Needless to say, the advent of the printing press gave thousands access to the power of the written word and spread literacy throughout the world. The printed word became a sacred body with intrinsic meaning. The discipline known as *typography* has evolved since Gutenberg as a practice that embodies the design, production, and application of interchangeable letterforms in order to convey a message to an audience.

Readers have certain expectations from a printed text, be it a book, magazine or newspaper—that it should have a static set of words that one can read and re-read; a fixed order of pages; portability, physicality, and permanence. The printed book still follows the principles and guidelines formalized in the 17th century: the text—a fixed discourse composed by an author—is usually contained in a sequence of printed and bound pages with a cover, title page, table of contents, chapters, and index. The role of time in the printed format is literally in the hands of the reader. The structural framework and formal qualities of a text remain static once printed, but the reader's disposition in relation to it may change.

Visual communication thrives at the crossroads of technology and culture. By considering the formats of television, film, video, computer you can see that new systems of recording, editing, transmitting, and receiving information have always influenced new paradigms of visual aesthetics even though the molecular components of communication—letters and text—have remained the same for thousands of years.

The mechanics of reading written and printed texts function according to the recognition of words to which meanings have been applied by cultural convention. This level of perception goes beyond simply recognizing the shape generated through the succession of single, two-dimensional letter forms. The totality of the word produces two meanings. One is related to the idea represented by the word itself, constructed from a string of letters—the word-image—and the other from its holistic visual manifestation—the typographic image.

In 1839, Louis Jacques Mandé Daguerre invented the process of capturing still images on silver plates using a camera. Paralleling the development of photographic technology was a simple toy known as a thaumatrope, from the Greek *thauma*, which means wonder, magic or miracle. The toy consists of a string which suspends a disc containing two images, one on each of its sides. When the disc is spun, the images are superimposed over one another and appear as a single image. This "perceptual" phenomenon is known as *persistence of vision*. The human eye holds on to images for a split second longer than they are actually projected, so that a series of quick flashes is perceived as one continuous image.

The thaumatrope, along with the photographic experiments in the 1870s of Etienne Jules Marey in France and Edward Muybridge in the United States, paved the way for the development of the motion-picture camera. The actual development of moving-image technology occurred simultaneously in England, France, Russia, and the United States in the late 19th century. The first practical machine for projecting successive images onto a screen was the praxinoscope, invented by Emile Reynaud in 1877. Subsequently, George Eastman developed the roll camera which replaced the cumbersome plate-image photographic technology with flexible, light-sensitive film. And in 1899, William Friese-Greene patented the first camera capable of capturing motion on a strip of light-sensitive film.

Frame-by-frame animation—the process of rendering each frame of film by hand to create a sequence of images the viewer sees as one continuous motion—plays an important role in the short history of time-based typography. Most of the early frame-by-frame animations were created as entertainment using illustrated characters rather than live action. Animators used hand-rendered, representational subjects in an attempt to provide the viewer with a simulated link to reality. They were usually domestic and farm animals—cats, dogs, mice, ducks—whose characterization and anthropomorphism meant a human audience could relate to them.

The use of text in film was originally limited to title cards—two-dimensional surfaces on which dialogue, announcements, warnings, news items, and credits were handwritten or printed—but the pioneer filmmaker, George Méliès, whose 1902 *A Trip to the Moon* remains a masterpiece of early motion-picture technology, experimented with animated letterforms in advertising films as early as 1899. Another pioneer, D.W. Griffith, incorporated title cards in his *The Birth of a Nation* (1915) and *Intolerance* (1916) both of which were considered narrative and structural breakthroughs in the history of the motion picture as an art form. In *Intolerance,* Griffith used a series of title cards as significant components of the film. Each card contained a composition of static letterforms superimposed over a photographic background that introduced the historic time-period about to be presented.

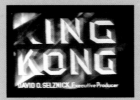

The makers of horror and monster films in the early to mid-20th century used title-card technology to establish the premise of their stories and evoke an emotional response which heightened the experience of the theater audience. In the classic 1933 film *King Kong*, massive jungle leaves provide a slow, wiping transition between the title cards printed with monumental letterforms to imply large-scale movement through an dense, mysterious environment. In the 1951 film *The Thing from Another World*, a darkened backdrop literally burns away and reveals streaking rays of vibrating light that pierce through the letterforms of the title and into a suspense-filled audience.

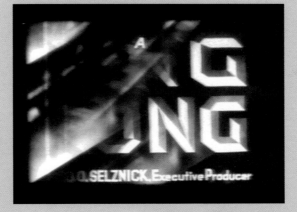

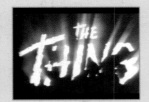

In the 1920s and 1930s, Walt Disney led technological advancements in animation by rendering smoother frame actions, synchronizing music, sound and dialogue, and incorporating color. But these efforts toward the perfection of realism caused a revolt among animators and designers who wanted to break creative boundaries. The advent of television technology and the exponential growth of the advertising industry in the early 1930s created a prime arena in which to experiment with film and animation. Instead of presenting static postcard realism in the background of a composition, commercial animators began incorporating symbolic and iconographic elements to create messages. Most specifically, they explored the use of letterforms. In the 1950s and 1960s, innovators such as Norman McLaren, Saul Bass, and Pablo Ferro used animation techniques to hand-render seamless compositions—and interactions—of type and image on film for television commercials, short films, and film titles.

Initially, animated letterforms were restricted to supporting roles: announcing the beginning of films, identifying television stations, or providing information in commercials. In 1961, the animator Norman McLaren brought the animated letterform to center stage in an advertisement commissioned by the Canadian Board of Tourism. McLaren used cut-out letterforms in a stop-motion animation sequence which was shown on the Sony Epok Animated Electric Screen in Times Square, New York, a 720-foot-square signboard made up of thousands of light bulbs activated by film. Type historian Beatrice Warde described it as follows:

"Do you wonder that I was late for the theater when I tell you that I saw two Egyptian A's...walking off arm in arm with the unmistakable swagger of a music-hall comedy team? I saw base serifs pulled together as if by ballet shoes, so that the letters tripped off literally sur les pointes...I saw the word changing its mind about how it should look (caps? lower case? italic?) even more swiftly than a woman before her milliner's mirror...after forty centuries of the necessarily static Alphabet, I saw what its members could do in the fourth dimension of Time, 'flux,' movement." [1]

2

The desk-top computer has opened doors and allowed humans to transform a predominantly passive communication experience into an interactive one, increasing the accessibility and control of information. Information has grown more complex and is now distributed by an overwhelming array of means. Digital technology represents a synthesis of all media which preceded it. Reading has become more complex with such concepts as simultaneity, immediacy, interactivity, intermedia, multimedia, hypermedia, hypertext, intertext, and verbal/visual/sound-bites.

Film and television are media that involve recording, editing, transmitting, and receiving image information, whether pictorial or textual; live action or static. Recording media, in its linear, filmic form, creates a direct path between the subject/content and the viewer. The development of non-linear interactive and immersive digitally based communication has enhanced, progressed, and distorted this path. Digital media takes recording media beyond the representation of reality and into the seamless manipulation of reality.

Consequently, the historical evolution of two-dimensional, static letterforms arranged and fixed in a horizontal string is shifting course. Type is no longer restricted to the characteristics found in the medium of print such as typeface, point size, weight, leading, kerning. Letterforms with behavioral, anthropomorphic and otherwise kinetic characteristics; text that liquifies and flows; three-dimensional structures held together by lines, planes and volumes of text *through* which a reader may travel—these are only a few examples of the impact digital technology is having on the once simple, humble letterform.

The page-frame as a compositional structure, with the conventional hierarchies of headings, columns, and margins is also expanding. In contrast to the materiality and permanence of the print medium, readers must now consider the roles of dimensionality, temporality, ephemerality, and transience, not a single, fixed frame, but sequences of frames that may or may not be consistent or even visually defined.

The *montage* and *collage* are two types of structures found in time-based formats. Montage structures involve the planning, assembling, and editing of a multi-frame sequence to create a narrative—a cause and effect or continuous series of events usually with a beginning, middle, and end. Here, letterforms serve both a verbal and visual function. Freezing a montage sequence captures a single moment in a larger continuous motion.

A collage is a more impressionistic—almost print-like—assembly of individual frames into a sequence without a fixed order of events. Here, letterforms are not always intended to be read but most always serve as components to a visually arresting typographic texture. Freezing a collage sequence reveals an individual, "stand-alone" composition much like a poster or painting.

So what should type that dances and bounces, metamorphosizes and dissolves before the human eye be called? A *printed* book on *moving* typography? Is this not a contradiction in technologies? Will not freezing a film sequence eternally onto paper diminish the impact that 24 frames per second can offer?

Here, we want to give form to an emerging discipline with four loosely related titles: *time-based typography, kinetic typography, dimensional typography, motion graphics*. All four categories are valid in that time, motion, dimension, and image all play an important role in the process of creating and reading type that exists solely on a computer, television, video or film screen. The examples presented in this book highlight the effect of these characteristics on the reader's traditional, print-based, static understanding of typographic form and communication. This includes the consideration of legibility and readability of text which is seen and/or read for a limited period; the invention of new creative and functional characteristics of typography, down to the structural nature of letterforms themselves; the development of a new language to understand and explain the relationship between new technologies and the letterform; and the exploitation of these technologies to raise visual communication to new levels. We hope you enjoy the work and ideas presented on these pages. — MW + JB

1. *Alphabet 1964: International Annual of Letterforms*, Hutchings, Reginald Sales, ed., Birmingham, England: The Kynoch Press, 1964
2. TITLE *New York Lightboard Animation* · FORMAT Black and White Film ORIGIN Canada · CLIENT Canadian Board of Tourism · DATE 1961 DESIGNER Norman McLaren · DIRECTOR Norman McLaren · PRODUCER Norman McLaren · ©1961 National Film Board of Canada

1 [Precedents]

The earliest application of kinetic typography is in film-title design. The collection of precedents here reveals a sense of history and also draws connections between visual innovations in 1959 and 1999. Commenting on the nature of creativity in a discipline that has seen several re-births, Pablo Ferro states, "There is nothing new anymore, only that which has been forgotten." If this is indeed the case, then it is necessary to provide benchmarks in the evolution of film-title design to show not how to imitate, but how to transcend with the aid of digital technology.

Type at Play

Norman McLaren worked at the National Film Board of Canada for more than 30 years and explored, developed, and refined techniques in hand-drawn—cameraless—film animation, and directed and animated ground-breaking films using optical printing effects.

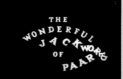

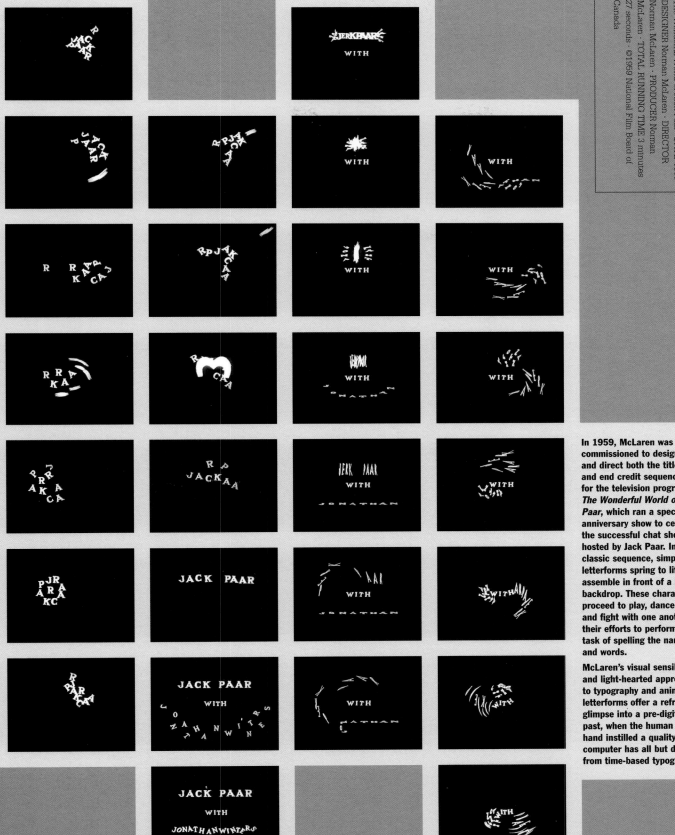

TITLE *Jack Paar Credit Titles* · FORMAT Black and White Film · ORIGIN Canada · CLIENT The Wonderful World of Jack Paar · DATE 1959 DESIGNER Norman McLaren · DIRECTOR Norman McLaren · PRODUCER Norman McLaren · TOTAL RUNNING TIME 3 minutes 27 seconds · ©1959 National Film Board of Canada

In 1959, McLaren was commissioned to design and direct both the title and end credit sequences for the television program *The Wonderful World of Jack Paar*, which ran a special anniversary show to celebrate the successful chat show hosted by Jack Paar. In this classic sequence, simple letterforms spring to life and assemble in front of a black backdrop. These characters proceed to play, dance, race, and fight with one another in their efforts to perform their task of spelling the names and words.

McLaren's visual sensibilities and light-hearted approach to typography and animated letterforms offer a refreshing glimpse into a pre-digital past, when the human hand instilled a quality the computer has all but deleted from time-based typography.

Graphic Symbolism

Saul Bass (1920–1996) was a pioneer who created vibrant sequences that transformed the function of film titles from pragmatic communication to complete mininarratives which used metaphor to establish the mood and visual character of a film.

The signature design methodology of Saul Bass embraced the modernist tenet of reduction and enforced an acute attention to pace, rhythm, and detail.

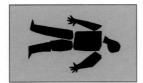

In order to exploit his keen sensitivity to concept and metaphor visually, Bass successfully integrated and unified several techniques in his title sequences, including photography, photomontage, split-screen wipes, and animation. Later, however, he grasped video and digital technology, and live action—which he preferred—and explored the complexities of layering type and image in a seamless environment.

The film adaptation of the musical *Carmen Jones* opens with a single flame burning behind a small drawing of a rose. The title, drawn in an energetic serifed letter style, remains static and centered, and functions more as a logotype. The flame establishes a cohesion of image and type by shifting back and forth to accommodate the variable lengths of the title treatment and remaining opening credits.

Bass's earlier sequences were traditional animations that used cell drawings or cut forms. The opening sequence of *Anatomy of a Murder* presents simple hand-cut shapes of body parts that shift in scale, and move and juxtapose one another to create abstract relationships before they assemble into a complete human body, sprawled as if found at a murder scene.

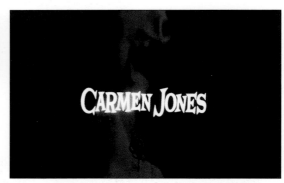

2

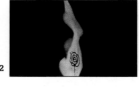
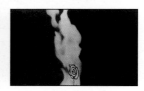

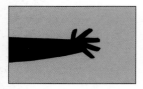

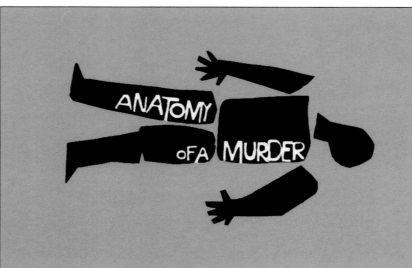

The modular function of the simple black shapes in *Anatomy of a Murder* are typographic as they assemble and re-assemble to create different compositional results. Edited to the jazz of Duke Ellington, Bass used these shapes to draw attention to the actual typography, either by reversing the sans serif typeface out of a shape or establishing directional lines that point to the credits.

1

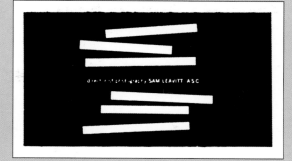

A graphic and industrial designer heretofore, I now found myself confronted with a flickering, moving, elusive series of moving images that somehow had to add up to communication. —Saul Bass, on designing his first film title.

After working for various advertising agencies and art departments, Bass began freelancing, and in the late 1950s was contacted by the filmmaker Otto Preminger to design the title sequence for *The Man with the Golden Arm.* Bass and the director began working on the title sequence with the idea that the film should start with the first frame, grab the audience from the moment the projector lights up, and establish the mood of the film, all of which were concepts far ahead of their time.

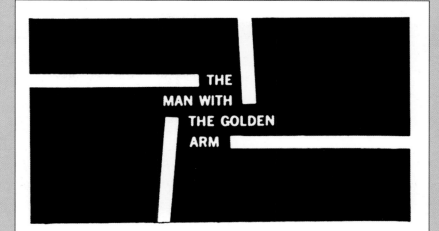

White rectangular bars dance around the frame in a loosely choreographed manner that draws attention to the title and credits, which are set in a subtle but effective all-capital sans serif typeface that has the same height as the bar widths.

3

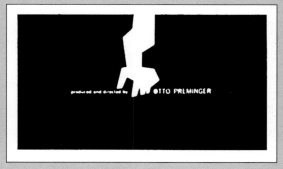

The bars converge vertically in the center of the screen, which creates a visual tension in the composition of the frame, before they synthesize into the now-famous reaching arm.

1. TITLE *Anatomy of a Murder* · FORMAT Film · ORIGIN United States · DATE 1959 · DESIGNER Saul Bass · DIRECTOR, PRODUCER Otto Preminger · EDITOR Louis R. Loeffler · DIRECTOR OF PHOTOGRAPHY Sam Levitt · COMPANY Columbia Pictures Corp. · ©1959 Carlyle Productions, Inc.

2. TITLE *Carmen Jones* · FORMAT Film · ORIGIN United States · DATE 1954 · DESIGNER Saul Bass · DIRECTOR, PRODUCER Otto Preminger · EDITOR Louis R. Loeffler · DIRECTOR OF PHOTOGRAPHY Sam Levitt · ©1954 Carlyle Productions, Inc.

3. TITLE *The Man with the Golden Arm* · FORMAT Film · ORIGIN United States · DATE 1956 · DESIGNER Saul Bass DIRECTOR, PRODUCER Otto Preminger · EDITOR Louis R. Loeffler · DIRECTOR OF PHOTOGRAPHY Sam Levitt · ©1995 Carlyle Productions, Inc. ©1989 Otto Preminger Films, Ltd.

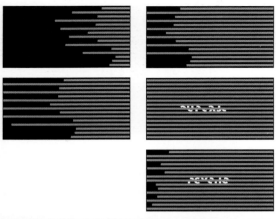

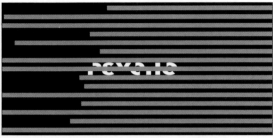

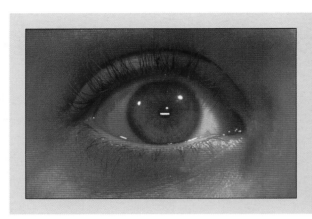

From Psycho to Vertigo

Psycho, the chilling mystery classic directed by Alfred Hitchcock, is one of Bass's most visually dynamic title sequences. Bold, crisp gray horizontal lines slide rapidly across the viewing frame and cover it completely.

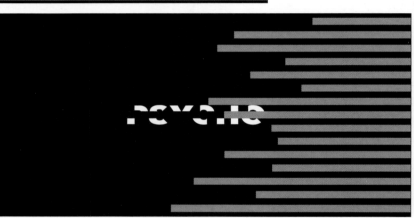

The main title treatment, set in an all-capital sans serif, bold typeface, appears horizontally severed and out of vertical alignment. The two sections of the title break apart slightly in a jerking motion, as if trying to find each other, which relates conceptually to the psychotic schizophrenia of the main character, Norman Bates, who thinks he is his mother.

The gray lines slide out of the frame, allowing the title sections to unite. The lines then re-emerge vertically in opposite directions from the horizontal center and completely cover the viewing frame, then move upward like a curtain to reveal the opening scene.

Then as the film proceeds, it becomes clear that the horizontal gray lines are a graphic metaphor for the opening scene which begins with an aerial zoom into the window of an apartment with partially closed venetian blinds. The vertical gray lines, on the other hand, are a metaphor for the final scene in which Norman Bates is put behind bars.

Bass also served as the pictorial consultant for the now-famous shower murder scene.

1

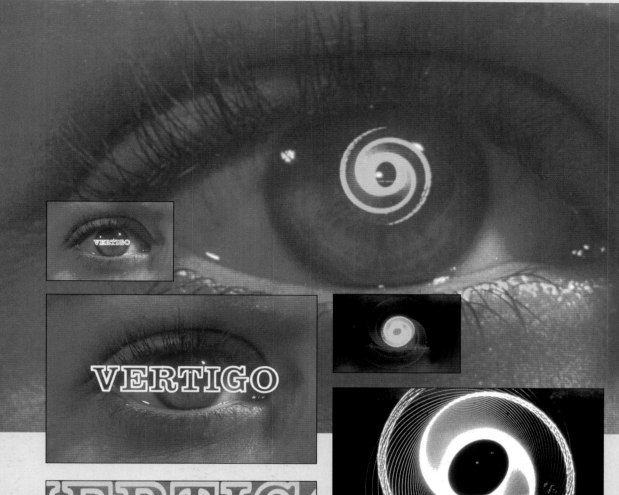

1. TITLE *Psycho* · FORMAT Film · ORIGIN United States · DATE 1960 · DESIGNER Saul Bass · DIRECTOR Alfred Hitchcock · EDITOR George Tomasini · DIRECTOR OF PHOTOGRAPHY John L. Russell · COMPANY Universal · ©1960 Shamley Productions, Inc.
2. TITLE *Vertigo* · FORMAT Film · ORIGIN United States · DATE 1958 · DESIGNER Saul Bass · DIRECTOR Alfred Hitchcock · EDITOR George Tomasini · DIRECTOR OF PHOTOGRAPHY Robert Burks · SPECIAL PHOTOGRAPHIC EFFECTS John P. Fulton · COMPANY Universal · ©1958 Alfred J Hitchcock Productions, Inc. and Paramount Pictures Corp.

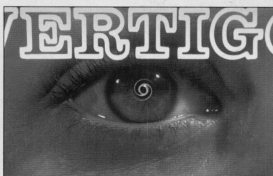

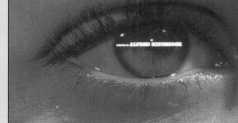

The camera pans up to a closely cropped face of a woman, and then zooms into her eye which becomes the focal point in the viewing frame. As a red hue envelopes the image, the main title treatment emerges from the center of the pupil and zooms forward out of the frame.

Following the title, a spinning, spiral-shaped web of lines zooms forward to capture the dizzying sensation felt by those afflicted with vertigo. The final credit, that of director Alfred Hitchcock, emerges from the woman's pupil, in a similar way to the main title, to end the sequence.

The main title and credits are set in a bold, outlined slab serif typeface. This highly functional typeface allows the letters of the title to be tightly spaced while maintaining readability and enhancing the visual impact of the sequence.

The opening sequence to the 1958 film *Vertigo* combines live action, typography, and advanced optical effects that compete with the capabilities of computer technology almost 40 years later.

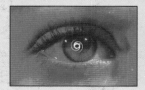

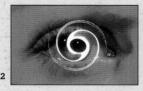

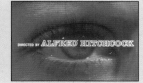

2

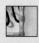

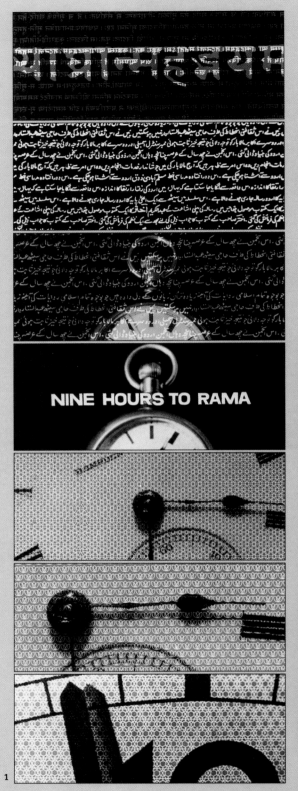

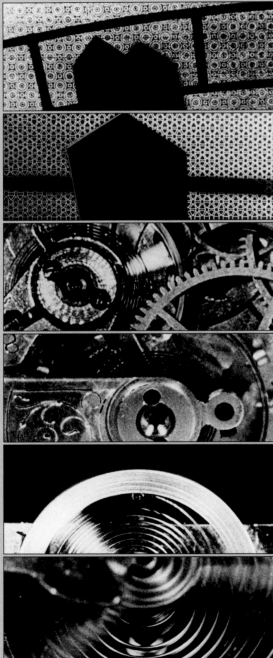

Bass uses the motions of the watch and the locomotive as metaphors for the unavoidable ticking away of Ghandi's last hours, minutes, and seconds. The title treatment, typeset in a functional sans serif, performs the minimal task of titling the film, but does not distract from the activity of images and textures to introduce the story.

Later in his career, Bass began using live action in his titles. The sequences Bass created using this approach actually became the first *scene* of the film, and introduced the audience to the plot as opposed to simply identifying the film.

Nine Hours to Rama is a film about the assassination of Mohandas K. Gandhi and the nine hours immediately preceding this tragedy. Marching strings of Hindi typographic characters provide a textured backdrop that opens the title sequence. An image of a stopwatch and the main title treatment fade in as the camera zooms to an extreme close-up of the watch. An intricate pattern of circles replaces the Indian characters as the camera continues its journey closer to the ticking second hand. The camera then takes the audience to the gear mechanisms inside the body of the watch before pulling back to focus again on the second hand as it transforms into the wheel of a locomotive.

1

Creating Visual Tension

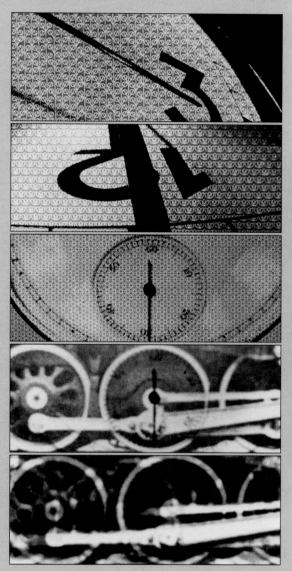

1. TITLE *Nine Hours to Rama* · FORMAT Film · ORIGIN United States · DATE 1963 · DESIGNER Saul Bass DIRECTOR Mark Robson · COMPANY 20th Century Fox

2. TITLE *West Side Story* · FORMAT Film ORIGIN United States · DATE 1961 · DESIGNER Saul Bass · DIRECTORS, PRODUCERS Robert Wise, Jerome Robbins · COMPANY Mirisch Pictures, Inc., in association with Seven Arts Productions, Inc. ©1961 Beta Productions, United Artists

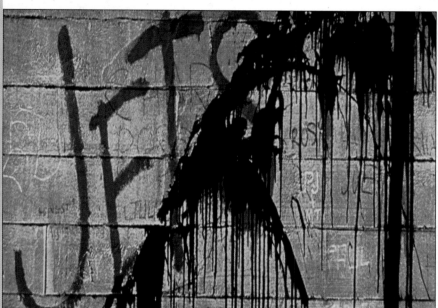

2

The title sequence for the film adaptation of *West Side Story* ingeniously uses the city surfaces in the film's background—walls, signage, fences, and doors—as the title cards with written, painted, and scrawled title and credits. The camera moves slowly across these surfaces and allows the audience to take in the setting and read the information.

The *Alcoa Première* title sequence, designed by Bass and his wife Elaine, evokes the mystery and drama of the stories depicted in this television anthology. The camera sweeps across a darkened landscape illuminated by circles and squares. The title emerges as the camera shifts its focus angle downward to expose the circles and squares as the tops of tall, slender monoliths. As the camera continues to move downward, details emerge which reveal that these structures are actually skyscrapers, and that the landscape is in fact a cityscape populated by the slightly taller, dimensional letters: A L C O A. The subtly revealed, but extreme shifts in scale, combined with low-intensity lighting effectively establish context and mood.

Building with Illumination

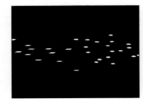 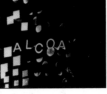 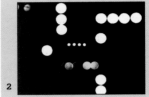

2

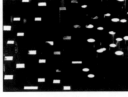 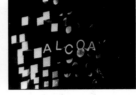

 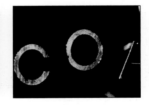

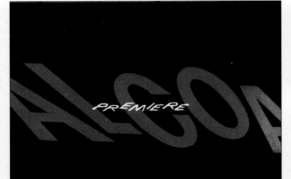

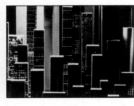

 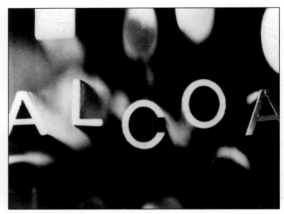

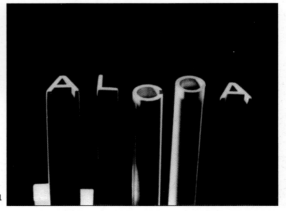

1

Spot-lighting

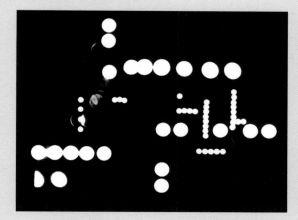

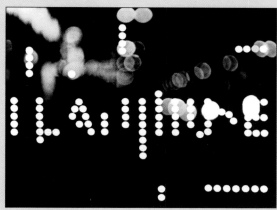

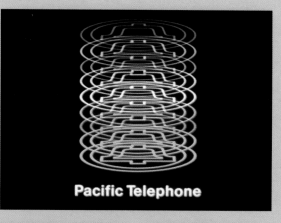

Pacific Telephone

South Central Bell

Northwestern Bell

The logo treatment for Bell Labs multiplies and adopts a rainbow of colors to express the divisions of what was once the ruler of the American telephone industry.

Illinois Bell

Diamond State Telephone

Southwestern Bell

Bell Labs

Bell Labs

Long Lines

AT&T

3

1. TITLE *Alcoa Première* · FORMAT Film, Video · ORIGIN United States · DATE 1961 · DESIGNERS Saul and Elaine Bass · ART DIRECTOR Saul Bass · COMPANY Saul Bass and Associates, Inc.

2. TITLE *Playhouse 90* · FORMAT Film, Video · ORIGIN United States · DATE 1960 · DESIGNER Saul Bass · ART DIRECTOR Saul Bass · COMPANY Saul Bass and Associates, Inc.

3. TITLE *AT&T Telephone Television Spot* · FORMAT Video · ORIGIN United States · DATE 1969 · DESIGNERS Saul and Elaine Bass · COMPANY Saul Bass and Associates, Inc.

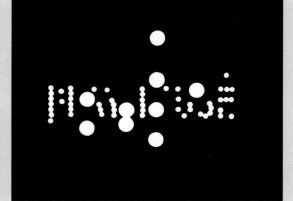

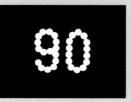

2

A pattern of lights creates the atmosphere of a city at night. The circular dots eventually merge to form letterforms that spell *Playhouse 90,* an American television program. As the words Playhouse and 90 flash alternately on the screen, the viewer's persistence of vision causes the words to appear as a multi-layered image, reminiscent of the famous lightboard in Times Square.

FILMS

Pablo Ferro began his creatively rich and highly influential career in the 1950s as an illustrator for Altas Comic Books. After a successful decade, Ferro brought his illustrations to life on film, producing commercials for a wide range of clients. In 1961, he formed a partnership with Fred Mogubgub and Louis Schwartz with the intention of bringing art to the television commercial. Ferro's creative editing which produced a rapid-fire barrage of exploding type and imagery became known as the "quick cut". Twenty years after Ferro developed this innovative technique, the music channel MTV adopted it as a signature to capture the fast-paced lifestyles of the channel's 18 to 30-year-old audience. As a result, Ferro became known as the *Father of MTV*. Today, he is still a film-title designer and collaborates closely with major studio directors and producers.

These frames are taken from a promotional film that announced the formation of Ferro, Mogubgub & Schwartz in 1961. Bold, slab-serif, cut-out letterforms, white on a black background, are the only characters in this stop-motion film—they perform for the viewer in a manner that captures the playfulness, creativity, and energy of what was to become the leading commercial studio in New York.

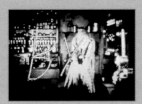

Scratching the Surface

Ferro pioneered many processes and special effects in his film work. Often, his treatments made the viewer aware of the medium itself, contradicting the technical advancements of film toward the ultimate clarity and representation of reality. This promotional film entitled *Quick Cuts '63* makes use of a technique in which each frame is hand-scratched with letters that spell music over live imagery. Ferro took this one step further by substituting clean-edged printing type forms to contrast with the rough gestural qualities of the hand-etched letters. When viewed in realtime, this "scratch film" reveals fragmented letterforms that sporadically jump around the viewing frame over a more consistent image activity in the background.

1. TITLE *FMS: opening titles for sample reel*
FORMAT Film · ORIGIN United States
1961 · DESIGNERS Jon Aron, Fred Mogubgub,
Pablo Ferro, Thinkaus, Aron & Wayman
DIRECTORS Pablo Ferro and Fred Mogubgub
MUSIC Bob Prince
COMPANY Ferro, Mogubgub & Schwartz
FRAME IMAGERY Supplied Courtesy of
The Title House, Los Angeles
2. TITLE *Quick Cuts '63* · FORMAT Film
ORIGIN United States · CLIENT American
Television Commercial Festival: The Clio
Awards · DATE 1963 · DESIGNER and
DIRECTOR Pablo Ferro · MUSIC Bob Prince
COMPANY Ferro, Mogubgub & Schwartz
FRAME IMAGERY Supplied Courtesy of The
Title House, Los Angeles

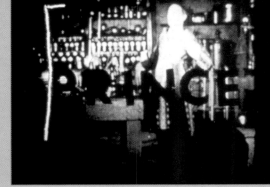

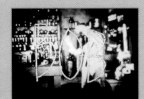

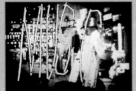

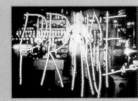

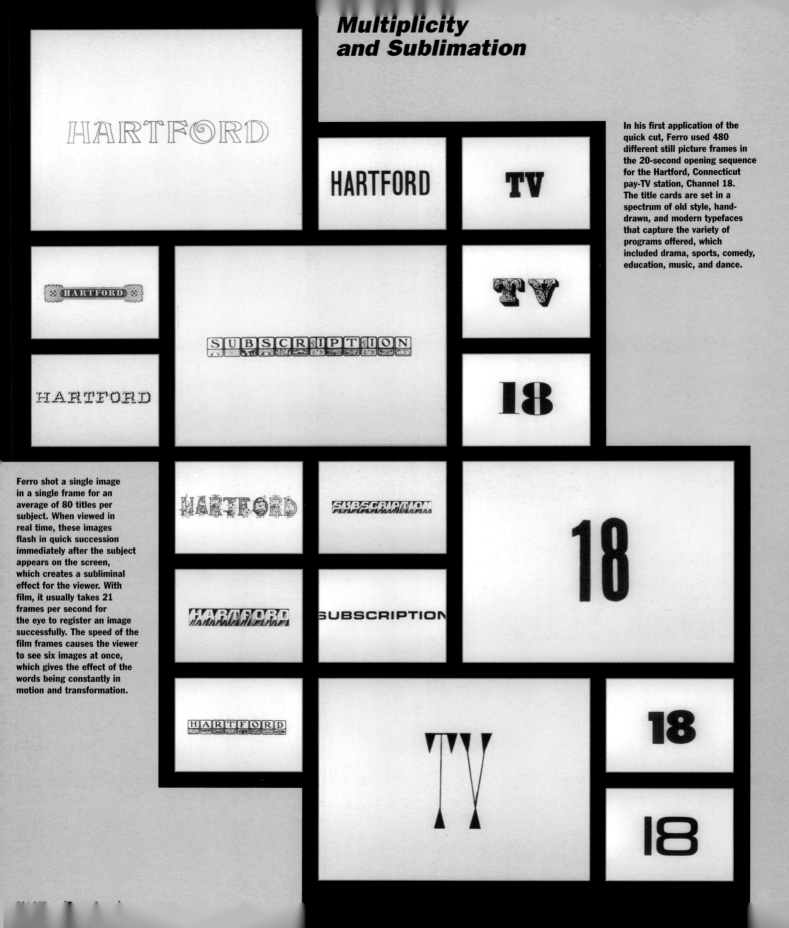

Multiplicity and Sublimation

In his first application of the quick cut, Ferro used 480 different still picture frames in the 20-second opening sequence for the Hartford, Connecticut pay-TV station, Channel 18. The title cards are set in a spectrum of old style, hand-drawn, and modern typefaces that capture the variety of programs offered, which included drama, sports, comedy, education, music, and dance.

Ferro shot a single image in a single frame for an average of 80 titles per subject. When viewed in real time, these images flash in quick succession immediately after the subject appears on the screen, which creates a subliminal effect for the viewer. With film, it usually takes 21 frames per second for the eye to register an image successfully. The speed of the film frames causes the viewer to see six images at once, which gives the effect of the words being constantly in motion and transformation.

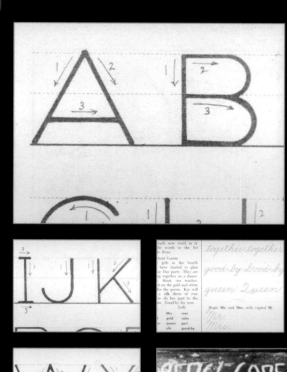

72. Let's Add and Subtract

1. TITLE *Channel 18 Station Opening* · FORMAT Film · ORIGIN United States · CLIENT Channel 18, Hartford, Connecticut
DATE 1962 · DESIGNER and DIRECTOR Pablo Ferro · ACCOUNT SUPERVISOR John Pinto · CONSULTANT John Donnelly
MUSIC Bob Prince · COMPANY Ferro, Mogubgub & Schwartz
FRAME IMAGERY Supplied Courtesy of The Title House, Los Angeles

2. TITLE *Channel 13: The Education Channel* · FORMAT Film · ORIGIN United States · CLIENT WNDT Channel 13, New York,
New York · DATE 1962 · DESIGNER and DIRECTOR Pablo Ferro · MUSIC Bob Prince · ARTISTS Irene Trivas, Charles B.
Slackman, Allen Ferro (aged 4½ years) · COMPANY Ferro, Mogubgub & Schwartz
FRAME IMAGERY Supplied Courtesy of The Title House, Los Angeles

Similar to the Hartford spot,
the opening for the première
of the first educational
channel in New York, WNDT,
Channel 13, compresses a
wide range of subjects from
literature, drama, science,
art, music, philosophy,
economics, and language to
religion into this unusually
long 3 minute and 26
second sequence.

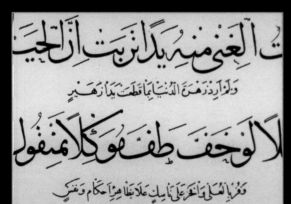

Typographic treatments
punctuate this continuous
flow of imagery which
includes material from a
variety of media: animated
and live action sequences,
clips from newsreels
and silent movies, still
photographs and original
artwork.

Psychedelia

This commercial spot for Tempo Peas is brought to by Ferro's quick-cut editin A montage of provocative typographic and image treatments gives the viewe a new perspective on the hopelessly simple vegetabl

see

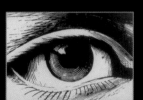

WHAT

Letterforms become harlequins and props in a fantasy carnival parade for this 1965 sequence, Jamboree. A series of colorful, semi-transparent, hand-painted still frames were layered and animated to create the effect of a merry procession.

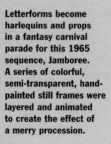

Y O U

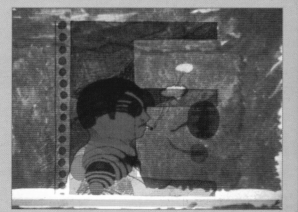

ARE

TTING

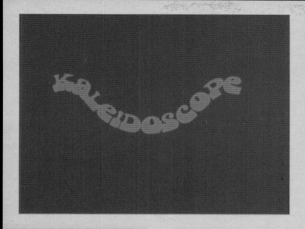

The title *Kaleidoscope* is set in an Art Nouveau typeface that naturally flows on a curved path, renders itself semi-transparent in various hues, multiplies into several layers, and increases in scale to create a trippy, psychedelic setting over period style-influenced, action-packed stills for this 1966 television trailer—SMASHING!

1. TITLE Jamboree · FORMAT Film · ORIGIN United States · CLIENT Norman Skinner/NMI · DATE 1965 · DESIGNER and DIRECTOR Pablo Ferro · MUSIC Randy Weston · ARTISTS Randall Enos, Virginia Fritz, Ramon Ferro and Vincent Cafarelli · COMPANY Ferro Films

2. TITLE Tempo Peas · FORMAT Film · ORIGIN United Kingdom · CLIENT J. Walter Thompson DATE 1962 · DESIGNER and DIRECTOR Pablo Ferro · ARTIST John Glashan · COMPANY Ferro, Mohammed & Schwartz · FRAME IMAGERY Supplied Courtesy of The Title House, Los Angeles

3. TITLE Kaleidoscope · FORMAT Film: television trailer · ORIGIN United States · CLIENT Dick Letterer/Warner Bros. · DATE 1966 · DESIGNER and DIRECTOR Pablo Ferro · COMPANY Ferro Films · FRAME IMAGERY Supplied Courtesy of The Title House, Los Angeles

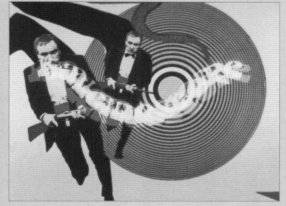

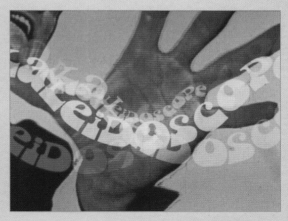

DR.

STRANGE LOVE

Compression and Fragmentation

I'm able to tell a 10-minute story in a minute.

—Pablo Ferro

Ferro brought his quick-cut technique to motion-picture trailer and title-sequence design, collaborating with the director Stanley Kubrick in his 1963 film *Dr. Strangelove*.

LEARNED

TO

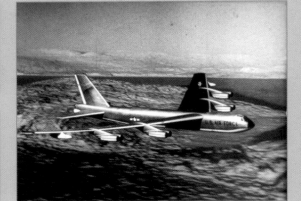

STRANGELOVE

STOP

BOMB

WORRYING

For this 1½-minute trailer Ferro used 40 different scene changes and eight different narrators, considering image, sound, and dialogue. Several versions of this sequence appeared in different settings: a 3-minute theater reel; a 1-minute television trailer; three 20-second television teasers, and two different-length versions for British television.

OR: AND ?

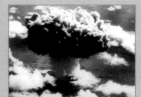

HOW LOVE

I THE DOES OBSESSED

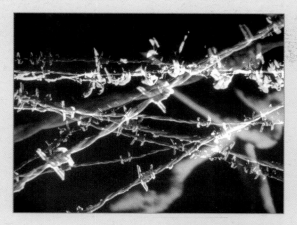

Type and image metaphorically capture the horrors of war in this sequence for the 1966 CBS television special *World War 1*. Criss-crossing strands of barbed wire fade in from a darkened backdrop. From the center of this ominous, but elegant tangle, and set in an all caps, bold, sans serif typeface, the title *World War 1* emerges as a dot and then grows larger as it moves toward the viewer until it becomes the only element in the frame.

1. TITLE *Dr. Strangelove or: How I Learned to Stop Worrying and Love the Bomb* · FORMAT Film trailer · ORIGIN United States · CLIENT Columbia Pictures · DATE 1963 · FILM DIRECTOR Stanley Kubrick · TRAILER PRODUCER/WRITER/EDITOR/MUSIC Pablo Ferro · TRAILER DIRECTOR and DESIGNER Pablo Ferro · COMPANY Ferro, Mohammed & Schwartz.
2. TITLE *World War 1* · FORMAT Film · ORIGIN United States · CLIENT Lou Dorfsman/CBS · DATE 1966 · DESIGNERS Lou Dorfsman, Pablo Ferro DIRECTOR Pablo Ferro · MUSIC Morton Gould · PRODUCER Pablo Ferro COMPANY Pablo Ferro. Films, Inc. · FRAME IMAGERY Supplied Courtesy of The Title House, Los Angeles

Ferro hand drew pencil-thin letters which interacted with, but did not obscure, the imagery of a jet refueling in mid-flight for the opening title sequence of the film *Dr. Strangelove*. Complete with the suggestive vocal soundtrack *Have a Little Tenderness*, this sequence represents the perfect synthesis of type, image, and music to set a humorously seductive mood for the film.

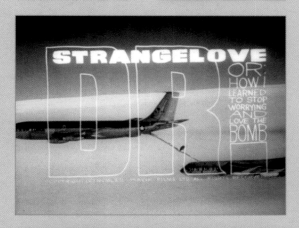

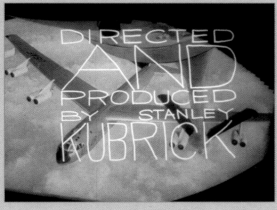

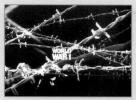

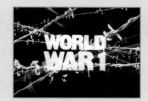

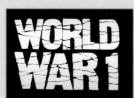

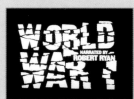

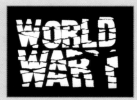

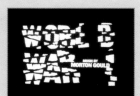

The title treatment forms cracks that resemble the pattern of the intersecting barbs. The letters then begin to fracture and crumble as the remaining credits peak through newly formed fissures.

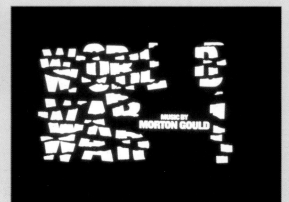

Atmospherics

Founded by the brothers Richard and Robert Greenberg in 1977, R/Greenberg Associates quickly emerged as second generation design innovators who closely followed the metaphoric footsteps of Saul and Elaine Bass in title and special effects. With the aid of new technologies combined with non-technical materials, R/GA created atmospheres and environments in which letterforms breathe, move, and metamorphosize.

R/GA has evolved into R/GA Digital Studios, a new media monolith that specializes in visual effects and design for live action films; CD-ROM games and online products; 2D and 3D digital and print production; and interactive products such as websites and information kiosks.

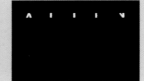

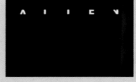

directed by Ridley Scott

The title sequence for the film, *Altered States*, opens with a close-up view of a scientist inside an isolation chamber. The proximity of the camera conveys a sense of confinement as the scientist's head moves within the viewing frame. The words altered and states are as tall as the screen and transparent, so that the image of the scientist is captured. The letters overlap each other as they move slowly across the viewing plane.

The opening titles for the film *Alien* establish an eerie, other-worldly atmosphere of mystery and danger. As the camera tracks across a darkened space pierced only by a vertical sliver of light, small, white rectangles appear. One by one, these simple objects gather on the scene until they form the letters that spell the word alien. These widely spaced letters are small in relation to the viewing frame which gives a sense of the vastness of space.

1

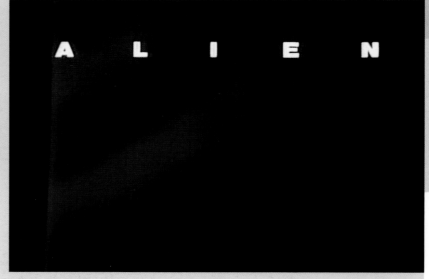

Starring Blair Brown

Film Editor Eric Jenkins

1. TITLE *Alien* · FORMAT 35 mm Film · ORIGIN United States · DATE 1979 · DESIGNER R/Greenberg Associates · DIRECTOR Ridley Scott · COMPANY R/Greenberg Associates
2. TITLE *Altered States* · FORMAT 35 mm Film · ORIGIN United States · DATE 1980 · DESIGNER R/Greenberg Associates · DIRECTOR Ken Russell · COMPANY R/Greenberg Associates

Starring Bob Balaban

Starring Charles Haid

Production Designer Richard McDonald

Music by John Corigliano

Produced by Howard Gottfried

Special Visual Effects Bran Ferren

Costumes Designed by Ruth Myers

Written for the Screen by Sidney Aaron
From the Novel *Altered States* by Paddy Chayefsky

The counters synthesize as the letterforms overlap which creates patterns of abstract shapes that contrast with the imagery inside the actual letterforms. The background behind the title fades to black as the camera slowly moves away from it. The film credits, which are smaller and white, are superimposed until the full title appears in its entirety with the remaining opening credits.

The title is set in the typeface Avant Garde Demi, with the right-angular stroke of the letter A deleted. This treatment of the A in both words unifies the title into an identity specific to the film.

ALTERED STATES
Directed by Ken Russell

2

Back-lit film animation was the technique used to simulate a burn-in of this 3D logo. The action of the hot fuse head as it traces the irregular edge of the drop shadow logo fits neatly with an energetic, synthesized sound track. The longevity of this sequence—still in use—is a testament to concept triumphing over technology, especially considering this could easily be made today with a desktop computer workstation.

TV Branding

The Boston public broadcasting station, WGBH, has been a pioneer, combining the medium of television with typographic experimentation to create memorable branding devices. The on-air signature for WGBH has been in use since 1976.

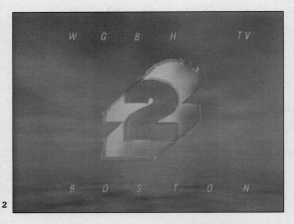

The companion to the WGBH logo, the highly visible 3D 2 used in program promotions, seasonal and holiday identities and special events, has flown over landscapes, been kicked by football players, baked as birthday cake, and lit like a firecracker.

2

A brilliant sunset image signifies the closing for *Goodbye to the 80's*, a series of short word-image spots WGBH ran during the last few months of 1989. A transparent glass plane provides the surface for the station identity, but also acts as a prism that transmits the orange, yellow, and blue filled sky through the 3D 2, and elevates it with a multi-dimensional, airy quality.

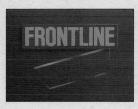

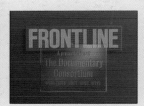

Frontline is a current affairs documentary produced by WGBH for PBS since 1983. The title sequence has the complex role of branding the series while framing a variable sequence of editorial elements including a tease, show title, funding and production credits. For this 1991 opening, computer-rendered, 3D, text-carved, transparent glass panels float into place over the opaque red Frontline logo, all set to a fixed musical underscore which has different versions for "soft" and "hard" subjects.

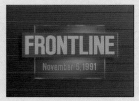

1

3

The opening title treatment for *Apollo 13*, a documentary about the ill-fated Apollo mission of 1970, begins with a distant earth seen from outer space. Separate bold sans serif type strings: Apollo, 13, To the Edge and Back enter the viewing frame at different ques from behind the audience, and rotate their way into a position centered in the frame. Although produced recently with digital technology, the titles take the viewer back to 1970.

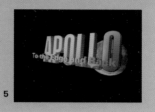

5

Learning from Comics

Don't Look Now was a pilot for a Sunday morning children's version of the popular skit-based comedy show *Saturday Night Live*. The opening sequence uses brightly hand-colored, cut-out letterforms and text animated over live imagery to give a cartoon caption feel to this fun, upbeat show for kids.

A photographer on roller-skates photographed the cast members on film as they ran through the WGBH studio building in order to capture the unpredictable directions and speeds of children at play. Selected images were made into color photocopies and then hand colored with markers and grease pencils. The artwork and type balloons were stop-motion animated separately and composited onto film in post production.

4

1. TITLE *WGBH On-Air Signature* · FORMAT Film, Video · ORIGIN United States · DATE 1976 · DESIGNERS Chris Pullman, Gene Mackles · MUSIC Gershon Kingsley · FILM ANIMATION Eastan Studios, New York · COMPANY WGBH Boston

2. TITLE *Goodbye to the 80's* · FORMAT Video · ORIGIN United States · CLIENT Caroline Collins, WGBH On-Air Promotion · DATE 1989 · DESIGNER Gene Mackles · MUSIC Gene Mackles; "We'll meet again" performed by the Ink Spots · 3D ANIMATION Viewpoint, Boston · COMPANY WGBH Boston

3. TITLE *Frontline* · FORMAT Video · ORIGIN United States · DATE 1991 · DESIGNERS Chris Pullman, Allison Kennedy · EXECUTIVE PRODUCER David Fanning · MUSIC Mason Deering · 3D ANIMATION Jamie McLellan · COMPANY WGBH Boston

4. TITLE *Don't Look Now* · FORMAT Film Animation, Video · ORIGIN United States · CLIENT Kate Taylor, WGBH Children's Programming · DATE 1983 · MUSIC Gene Mackles · DESIGN, PHOTOGRAPHY & ANIMATION Paul Souza · ANIMATION CAMERA Ed Joyce, The Frame Shop · COMPANY WGBH Boston

5. TITLE *Apollo 13* · FORMAT Video · ORIGIN United States · DATE 1994 · DESIGNER Allison Kennedy · 3D ANIMATION Frank Capria, WGBH; Viewpoint, Boston · PRODUCERS Noel Buckner, Rob Whittelsley · EXECUTIVE PRODUCER Zvi Dor-Ner · COMPANY WGBH Boston

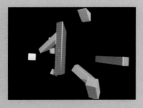

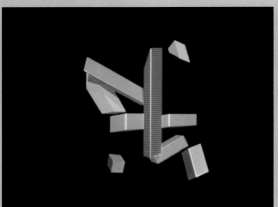

3D and Animated TV Branding

Martin Lambie-Nairn is an internationally acclaimed graphic designer and art director who specializes in the field of television brand identity. His pioneering efforts utilize innovative technologies to create precedent-setting visuals that have influenced the look of television branding worldwide.

1

A darkened, spinning globe provides a mysterious atmosphere which engulfs the classic and distinctive logo of the British Broadcasting Corporation's flagship channel—BBC1.

Channel Four was the first new British television channel to be established since BBC2 in 1964. The Channel Four identity was the first corporate identity specifically devised to exploit the medium of television to the fullest and to provide effective branding devices which could be developed as the character of the channel evolved.

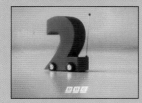

In 1991, BBC2, the BBC's "highbrow" channel underwent massive restructuring both in terms of its output and positioning. A key part of the strategy was a revamp of the channel's identity, giving the numeral "2" a tangible personality.

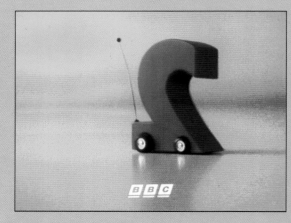

In this sequence, the 2 has acquired hot-rod accessories complete with stylized "chrome" wheels and a radio antenna. This super-charged 2 zips back and forth in a fiery red and yellow landscape. As it draws closer to the viewer, the renegade numeral does a wheelie before exiting the screen.

3

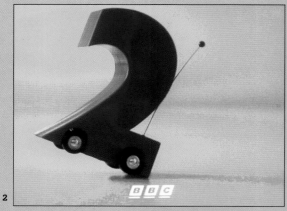

2

The modular symbol was designed to represent the diversity of Channel Four's program sources, all of which originate from outside the company itself. In this sequence, the various parts converge in space to assemble the numeral 4. Produced in 1982, this was the first time pure computer animation techniques had been used for a UK television company symbol.

Lambie-Nairn was commissioned to create a brand identity for Carlton that needed to reflect the values and lifestyle of a primarily metropolitan audience. Carlton had to be shown to be witty, playful, and aspirational.

A series of flexible idents was created that positioned the Carlton logo in center stage. In this sequence the unsuspecting logo is victim to its own letter O thrown at it like a pie in the face.

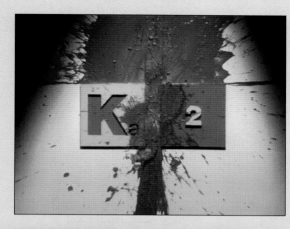

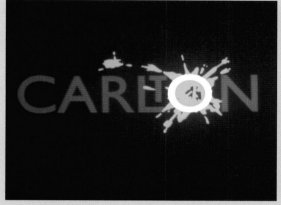

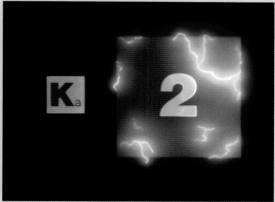

4

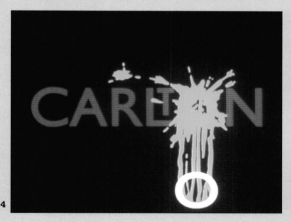

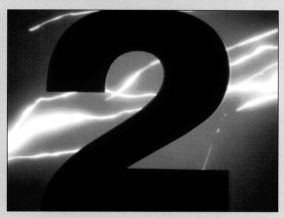

In 1995, Vlaamse Televisie Maatschappij (VTM), the first Flemish commercial channel to offer entertainment programming in Flemish, launched a new youth-oriented channel. The channel logo, positioned as the main character in these frames, captures the pace and energy of a younger age group in vibrantly colored actions that use water, paint, fire, lens flares, and electrical sparks.

5

1. TITLE BBC1 Brand Identity · FORMAT Video · ORIGIN United Kingdom · CLIENT British Broadcasting Corporation · DATE 1991 · CREATIVE DIRECTOR Martin Lambie-Nairn · DESIGNER/DIRECTOR Daniel Barber · ACCOUNT DIRECTOR Sarah Davies · PRODUCER Celia Chapman · COMPANY Lambie-Nairn @ The Brand Union · FRAME IMAGERY ©1991 Lambie-Nairn
2. TITLE BBC2 Brand Identity · FORMAT Video · ORIGIN United Kingdom · CLIENT British Broadcasting Corporation · DATE 1993 · CREATIVE DIRECTOR Martin Lambie-Nairn · PRODUCER Celia Chapman · COMPANY Lambie-Nairn @ The Brand Union · FRAME IMAGERY ©1993 Lambie-Nairn
3. TITLE Channel Four Brand Identity · FORMAT Video · ORIGIN United Kingdom · CLIENT Channel Four · DATE 1982 · CREATIVE DIRECTOR Martin Lambie-Nairn · ACCOUNT DIRECTOR Ian St. John · PRODUCER Sarah Davies · COMPUTER ANIMATION Tony Pritchett and Information International, Inc. · MUSICAL COMPOSER David Dundas · COMPANY Lambie-Nairn @ The Brand Union · FRAME IMAGERY ©1982 Lambie-Nairn
4. TITLE Carlton Television Brand Identity · FORMAT Video · ORIGIN United Kingdom · CLIENT Carlton Television · DATE 1996 · CREATIVE DIRECTOR Martin Lambie-Nairn · DESIGNER/DIRECTOR Charlotte Castle · ACCOUNT DIRECTOR Celia Chapman · PRODUCER Linda Farley · COMPANY Lambie-Nairn @ The Brand Union · FRAME IMAGERY ©1996 Lambie-Nairn
5. TITLE Ka2 VTM Brand Identity · FORMAT Video · ORIGIN Belgium · CLIENT Vlaamse Televisie Maatschappij (VTM) Ka2/Rhombus Media · DATE 1995 · CREATIVE DIRECTOR Brian Eley · DESIGNER/DIRECTOR Jason Keeley · ACCOUNT DIRECTOR/PRODUCER Celia Chapman · STRATEGIC PLANNER Terry Watkins · COMPANY Lambie-Nairn · FRAME IMAGERY ©1995 Lambie-Nairn

2 [Narrative]

A well-made feature film seizes the attention of the audience from the moment the projector bulb illuminates the screen. The opening title sequence captivates by establishing context, mood, and drama through an integration of words, images and sound travelling at 24 frames per second. This chapter considers the role of kinetic typography in a narrative situation, finding its most visible application in film-title design. Digital technology has replaced pre-printed title cards to allow letterforms to adopt poetic and cinematic qualities in order to tell a story verbally and visually.

Capturing Psychosis

With the creative mind of Kyle Cooper, New York-based R/Greenberg Associates have pioneered the syntheses of many new technologies with design innovation to produce precedent-setting film titles and special-effect graphics for film and television—two media long suffering from typographic inflexibility.

Seven is about a meticulous serial killer and his relationship with two detectives who are trying to catch him. In many ways, the opening sequence for *Seven* is responsible for a renewed interest in the importance of film-title design on the part of producers, directors, viewers, and thousands of design students in a historically conservative film industry.

The replacement of the V with the numeral 7 creates an identity that exists seamlessly between word and image: SE7EN.

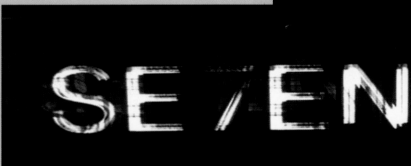

Infused with the fast-paced, hard-driving, horror-influenced music of Nine Inch Nails, the sequence intentionally instills a feeling of unease in the viewer.

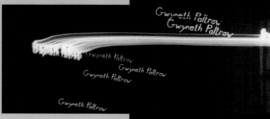

TITLE *Seven* · FORMAT 35 mm Film · ORIGIN United States · DATE 1995 · DESIGNER Kyle Cooper · DIRECTOR David Fincher · COMPANY R/Greenberg Associates

The significant achievement of this sequence is that the viewer is not only provided with effectively tense type treatments, but is made aware of the blatant manipulation of the medium which is used: film. This approach has since been mimicked and ultimately rendered a mere style by designers who respond to the formal qualities without considering the content and message at hand.

The credits, hand-scratched into the film, sporadically appear and overlap, pushing the limits of legibility. This activity overlays a close-up of a hand carefully cutting and pasting words and phrases with a razor blade. The contrast establishes a tension between the meticulous behavior of the serial killer while he plans his conquests and the ultimate violence he thrusts upon his victims.

The closing credits continue the same typographic antics as the opening by breaking some set-in-stone rules: the closing credits scroll up from the bottom to the top of the viewing frame as opposed to the traditional method of scrolling down.

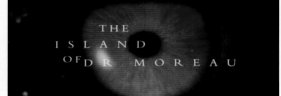

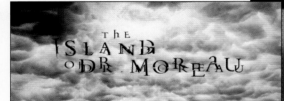

The opening titles for *The Island of Dr. Moreau*, a film based on H.G. Wells's story about genetic engineering gone wrong, begin with a slow pace and rhythm. The text exhibits very little directional movement, but fades in and out on a black screen. By the time the title of the film appears, over the closeup of an eye, the pace has become a rapid-fire of imagery and type. Extreme close-ups of imagery flash behind the pulsating text to offer a journey through a collage of humans, wolves, cats, dogs, and micro organisms.

Fracture and Metamorphosis

Juxtaposed over a series of quick cuts, the typography begins to metamorphize itself, much like the characters in the film. The title continues to fracture and break up until it becomes unreadable, as the parts of each letterform zoom toward the screen and past the audience. At this point in the sequence, the pace and rhythm have picked up considerably, and a succession of quick cuts of images crescendo until the last credit is displayed.

The fractured letterforms, which rotate and change position sporadically, reflect the "genetic mistakes" that live on the island. In the story, Dr. Moreau believes that evil exists inside the genes of humans, so much of the imagery in the title sequence is made up of microscopic cells and the fleshy insides of the body. Unfortunately, the film does not live up to the expectations given by this densely layered, yet highly intricate, sequence.

TITLE The Island of Dr. Moreau · FORMAT 35 mm Film · ORIGIN United States · DATE 1996 DESIGNER Kyle Cooper · DIRECTOR John Frankenheimer · COMPANY R/Greenberg Associates

Tones, Shifts, and Speed

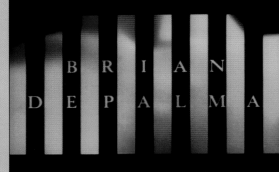

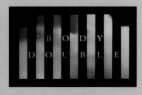
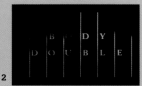

True Lies is a film about a man with two lives—by day he is a top government spy and by night, a mild-mannered, suburban, middle-class husband and father.

The title sequence captures this premise through typography: four blue shapes appear on blackened screen, and rotate to reveal the word true. The letterforms rotate again to reveal the word lies. The three-dimensionality of the letterforms allows an interplay between letterform and counterform to trick the eye into seeing solid instead of void and vice versa.

1

Body Double revolves around the story of a man who thinks he is secretly watching a woman through her apartment window when in fact he is being allowed to watch, and then when she is murdered he becomes the main suspect. In this sequence, the letters of the director's name, Brian De Palma, set in an elegant, serifed typeface, are separated by eight vertical bars that contain live, close-cropped and semi-blurred imagery of a nude human body. The bars then shift, as if pulling aside a window blind, to reveal the title of the film: *Body Double*.

2

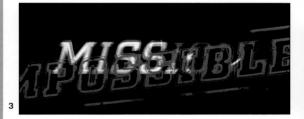

3

The title sequence for the film *Mission Impossible* reflects the fast pace of this action adventure, based on the popular television series of the 1960s.

The main credits are set in an oblique slab serif centered in the viewing frame. In the background, a much larger version of the same text, semi-transparent and layered several times, rushes horizontally from left to right, to capture the speed and force of the film.

The main title uses the same treatment as the credits. Mission enters from the left, positions itself just in time to be read before impossible stamps it like a passport. The title pair then zoom toward the front frame and beyond, trailed by a blurred ghost of their forms.

1. TITLE *True Lies* · FORMAT 35 mm Film · ORIGIN United States DATE 1994 · DESIGNER Kyle Cooper · DIRECTOR James Cameron COMPANY R/Greenberg Associates

2. TITLE *Body Double* · FORMAT 35 mm Film · ORIGIN United States · DATE 1984 · DESIGNER R/Greenberg Associates DIRECTOR and PRODUCER Brian De Palma · COMPANY R/Greenberg Associates

3. TITLE *Mission Impossible* · FORMAT 35 mm Film · ORIGIN United States · DATE 1996 · DESIGNER Kyle Cooper · DIRECTOR Brian De Palma · COMPANY R/Greenberg Associates

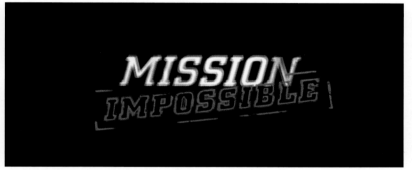

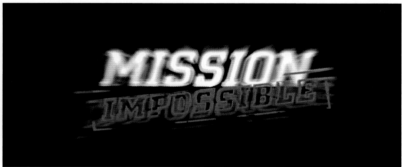

Seeing Sound

The MIT Media Laboratory conducts a wide range of research within an applications-oriented environment organized into three sections: Information and Entertainment; Perceptual Computing; Learning and Common Sense. Within these sections, faculty and research fellows pursue topics associated with the science, technology, and aesthetics of human communication and human–machine interaction.

The animation on these pages was produced as part of the Brain Opera, developed at the MIT Media Laboratory under the direction of Tod Machover. During the second movement of the opera, the music revolves around the words of Marvin Minsky and his Minsky Melodies as he muses about music and the mind. Because of the importance of the lyrics to the composer, he wanted the words to be understood, even when sung in an allegro form. A characteristic of this type of singing is that it is sometimes difficult to listen to the musical composition and fully understand the words at the same time.

OPERA

We don't

four generations

400 seasons

five scores

music

thinking

TITLE *Brain Opera*. ©1997 MIT · FORMAT Digital Media · ORIGIN United States
DATE 1997 · PERFORMERS Minsky Melodies · ANIMATION David Small and
Yin Yin Wong · MUSIC COMPOSER Tod Machover · LYRICS Marvin Minsky
SOPRANO Carol Bennett · BARITONE Christopher Nomura
SOFTWARE Yin Yin Wong, Doug Soo, Suguru Ishizaki, David Small
UNIVERSITY Massachusetts Institute of Technology Media Laboratory

any ξ {theories} music
not mysterious seem music
good ∇
scientifically

rhythm rhythm thm
rhy thm
rhythmrhythm thm thm rhy
rhy thm
thmrhy rhy
thmrhy thm
rhy
You don't see animals tapping their feet to

uses

about
about about about kid
music
about music
thinkabout thinkabout thinking music
music thinking thinkabout
about thinking SIC about
about music thinking thinking music about

meaningful its like seems it
you can't stop relating it to things
thing natural a not is it
every part of your brain has to make sense of it

Animated typography is used
to prime the audience to hear
the lyrics visually. As the
words are vocalized, the same
words dance and perform
on a large screen behind
three musicians. Visually rich
treatments of typography play
as musical counterpoints to
the words being sung.

The perceptual synchronization
between seeing and hearing
is achieved through
motion which is used to
elucidate multiple overlapping
voices. Computer animation
techniques visually enhance
the inflection, tone of
voice, mood, and meaning
of the lyrics.

androgyny

androgyny

being simultaneously; however, the counterclockwise twin broke through sac and separated prematurely ll term the wiser twin emerged. Each twin formed a unitary entelechy, a single living

androgyny androgyny

taneously; however, the f kwise twin broke lthrough separated prematurely in the wiser twin emerged. Each twin formed a unitary

which will transform the h into the successful teaching designed to be. We will exp

The One was and was-not, combined, and desired to separate the was-not from the was. So it generated a diploid sac which contained, like an eggshell, a pair of twi

The One was and was-not, combined, and desired to separate the was-not diploid sac which contained, like an eggshell, a pair of twins, each an androgyny, spinning in opposite directions. The plan of the One was that both twins would emerge into being simultaneously; however, the counterclockwise twin broke thro the sac

separate the was-not diploid sac which contained, like an eggshell, a pair of twins, each an androgyny, spinning in opposite directions. The plan of the One was that both twins would emerge into being simultaneously; however, the counterclockwise twin broke through the sac and separated prematurely At full term the wiser twin emerged.

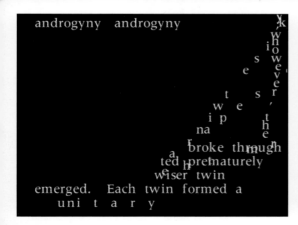

Valis, based on the book by
Philip K. Dick, is an opera
for six voices, hyperkeyboard,
hyperpercussion and
live computer electronics
composed by Tod Machover.
The simple, white, serifed
text dances and zooms
on a black backdrop as
a counterpart to the dense
verbal texture that exists
on the opera soundtrack.

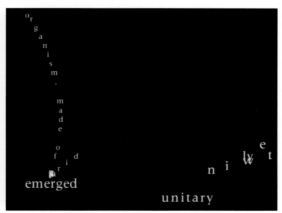

Typographic Opera

PROJECT *Valis* · FORMAT Video, Projection · ORIGIN United States · CLIENT Centre Georges Pompidou,
Paris · DATE 1989 · DEVELOPER John Underkoffler · COMPOSER Tod Machover · UNIVERSITY MIT Media
Laboratory

Mood-altering Understatement

New York-based Bureau, co-founded by Marlene McCarty and Donald Moffett, is a design studio which specializes in print products and film titles. Bureau works specifically with independent filmmakers, which often allows more creative freedom in the design process and the end product.

For his thirtieth anniversary the clothes designer Geoffrey Beene produced a feature-length movie, titled *30.*, instead of a runway show. The film was shot in black and white to capture the essence of an old classic movie.

In this sequence, the numeral 30 is set in a bold sans serif typeface—a style used early in the 20th century. The 30 flickers from the light of the film projector and fills the screen and slowly moves at an angle into a horizon determined by the name Geoffrey Beene, as if displayed on a marquee outside the theater.

1

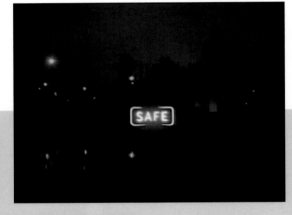

The film *Safe* centers around the main character's "environmental disease" and eventual retreat to a safe haven in the country. The opening sequence for the film places the viewer in a car driving through the streets of suburban Los Angeles. Bureau chose to center the title treatment in the frame and make it small in relation to the dark backdrop of imagery. The letters of the title are enclosed within brackets to give the viewer an idea of the film's premise. The title brightens to a hot white before fading to red, like a warning light in a vehicle alerting the driver to an impending problem. The end credits are creative—focusing on the small lighted center of the viewing frame.

2

The Ice Storm opens with a train slowly rolling down an icy New England track at night. Close-up shots of the icicle-covered underside of the passenger cars establish a sense of the slow passing of time. The opening credits, set in a simple sans serif typeface, fade in and wisp away over this imagery as gently as white breath on a cold day.

1. TITLE 30 · FORMAT 35 mm, 16 mm, and Super 8 Film · ORIGIN United States · CLIENT Geoffrey Beene · DATE 1993 · DESIGN Bureau, NY
2. TITLE *Safe* · FORMAT 35 mm Film · ORIGIN United States · CLIENT Chemical Films, Sony · DATE 1995 · DESIGN Bureau, NY
3. TITLE *The Ice Storm* · FORMAT 35 mm Film · ORIGIN United States · CLIENT Fox Searchlight · DATE 1996–97 · DESIGN Bureau, NY

3

Projection
and Reflection

Words slowly sneak across a cluttered office desk, stretching, bending, and rippling to the contours of a stapler, computer keyboard, and scattered papers. A water cooler, a photo-copier, an ashtray exploding with

cigarette butts, and a pool of blood all become victims to the opening credits in this tense, intriguing film-noir title sequence designed for *Office Killer*.

In order to set the viewer up emotionally for what will follow Bureau chose a highly legible, bold sans serif typeface to avoid distracting from the treatment of the letters as they prowl the unsuspecting office space.

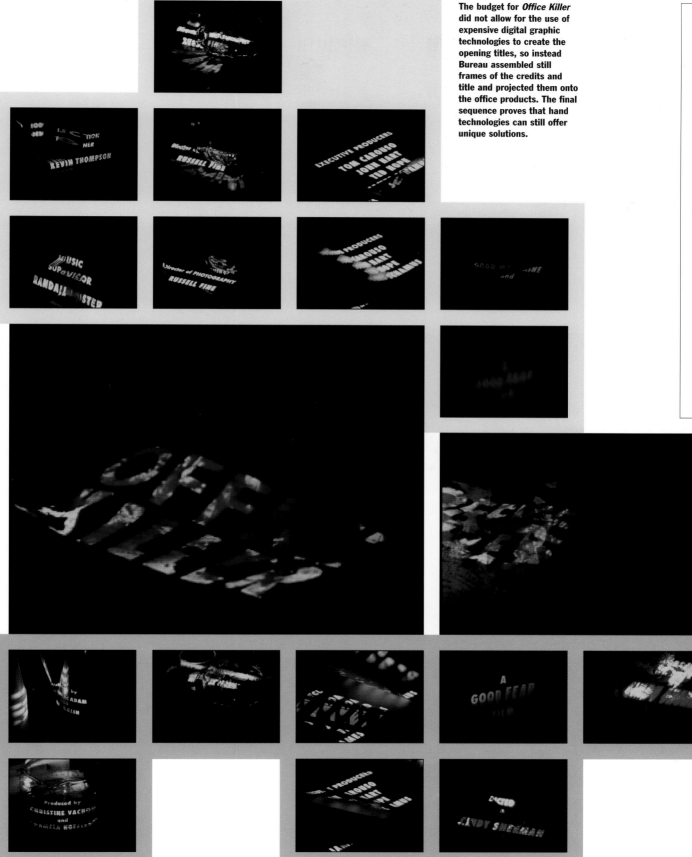

The budget for *Office Killer* did not allow for the use of expensive digital graphic technologies to create the opening titles, so instead Bureau assembled still frames of the credits and title and projected them onto the office products. The final sequence proves that hand technologies can still offer unique solutions.

TITLE *Office Killer* · FORMAT 35 mm Film · ORIGIN United States · CLIENT Killer Films · DATE 1998
DESIGN Bureau, NY · DIRECTOR OF PHOTOGRAPHY Russel Fine

Drama and Impact

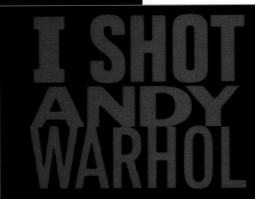

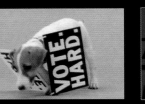

Propaganda

The above sequence, an *MTV Top of the Hour* spot, was designed to dovetail with 'Rock the Vote', a campaign that urged 18 to 22 year olds to vote during the 1996 American Presidential election. With an inventive use of title cards, playful pets grab the viewer's attention by literally carrying (and stumbling over, and biting, and sitting on) the message.

The main title treatment for the film *I Shot Andy Warhol* establishes itself in the viewing frame before moving forward and eventually sending the viewer through the space between the letterforms. The dramatic increase in size combined with cropping out of the viewing frame render the letters and background into simple shapes of black and red. This provides a backdrop for a recognizable typewriter-style typeface to present the remaining opening credits.

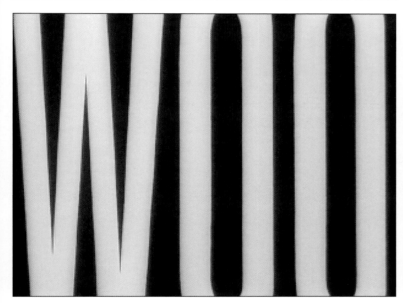

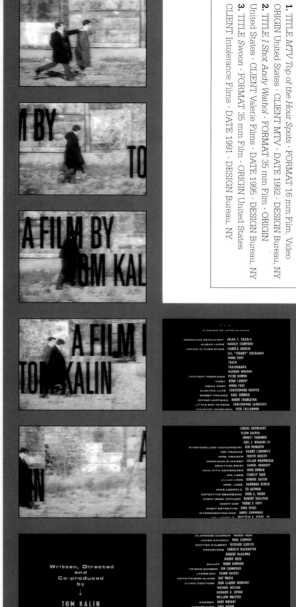

1. TITLE *MTV Top of the Hour Spots* · FORMAT 16 mm Film, Video · ORIGIN United States · CLIENT MTV · DATE 1992 · DESIGN Bureau, NY

2. TITLE *I Shot Andy Warhol* · FORMAT 35 mm Film · ORIGIN United States · CLIENT Valerie Films · DATE 1995 · DESIGN Bureau, NY

3. TITLE *Swoon* · FORMAT 35 mm Film · ORIGIN United States · CLIENT Intolerance Films · DATE 1991 · DESIGN Bureau, NY

The title treatment for the film *Swoon* performs in a similar manner to that of *I Shot Andy Warhol.* Set in a combination of upper and lowercase letters, the title is both elegant and intimidating, which is a perfect reflection of the main characters in the film: two attractive young men who become murderers. The remaining opening credits continue by moving horizontally across the frame in opposite directions over imagery of the two characters walking.

The end credits break away from film's traditional center-justified treatment, following the snaking curves of the letter S.

The opening title sequence for the film *Ratchet* embraces the action of a ratchet wrench. Set on a simple black background, the credit elements are in a white sans serif type aligned around a circle. The elements appear one by one in arcs moving clockwise around the circle to give the impression of rotation.

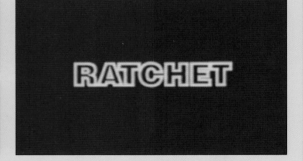

The title treatment is set in a thick sans serif outlined typeface against a solid blue background. The word ratchet appears small scale in the vertical center of the frame. The openly spaced letters slowly move forward and closer to one another until they overlap in a combination of line and shape to cast the impression of tightening and tension.

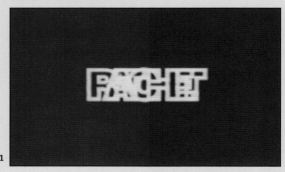

1

The closing credits continue the opening theme by interlocking with one another in rectilinear patterns that get brighter and fade into the stark black background.

2

The opening sequence for *Postcards from America* places the audience inside an automobile staring out of the windshield into a desert landscape as the sun peaks over the distant clouds, glowing a brilliant orange. One by one, the four words in the title emerge from the horizon, each set in a different typeface and color to convey the idea of a random collection of postcards from a journey. The remaining opening credits are all set in caps with a heavy sans serif typeface and arranged at right angles with the corner centered and facing out of the frame to enhance the vast landscape through which the audience travels.

1. TITLE *Ratchet* · FORMAT 35 mm Film, Silicon Graphics Animation · ORIGIN United States · CLIENT Altar Rock Films · DATE 1996 · DESIGN Bureau, NY

2. TITLE *Postcards From America* · FORMAT 35 mm Film · ORIGIN United States · CLIENT Islet Films · DATE 1994 · DESIGN Bureau, NY

3

Blurring Meaning

p2, a design studio based in New York City, has assembled a portfolio of commercial and personal work stemming from a wide range of media including print, digital, and motion graphics for film and video. Some of their more dynamic work comes from their experimental videos which run fast and free from the constraints dictated by clients and commerce.

Motion Graphics

The images on this page are from the opening sequence to the *p2 Self-Promotional Video* in which a synthesis of word and image are used in poetic and narrative structures.

1

1. TITLE *p2 Self-Promotional Video* · FORMAT Video · ORIGIN United States · DATE 1998 · DESIGNERS Matthew Pacetti, Christopher Pacetti · COMPANY p2
2. TITLE *p2 1990:96 Variations Electronic Portfolio* · ORIGIN United States · DATE 1996 · DESIGNERS Matthew Pacetti, Christopher Pacetti · FORMAT Digital Media · COMPANY p2
3. PROJECT *Untitled Experimental Video* · FORMAT Video · ORIGIN United States · DATE 1998 · DESIGNERS Matthew Pacetti, Christopher Pacetti · COMPANY p2

p2 has a fresh approach to contemporary design, undermining the style and surface treatments made popular by David Carson and Tomato. Instead of simply applying an effect, p2 moves several steps further and looks at content more carefully in order to achieve formal conclusions. They actually consider *what* they are saying in addition to *how* they are saying it.

(2) Lines of text describing the p2 design methodology are cut and pasted in quick succession in the opening sequence of their *p2 1990:96 Variations Electronic Portfolio*. This typographic treatment reflects the experimental nature of the intuitive processes of p2. In response to the content, they deliberately break the overly enforced "rules" of typographic commerce by fracturing the reader's notion of legibility.

(3) p2 builds upon the ideas at the root of concrete poetry and Fluxism, but in a contemporary context with time-based media. In the project to the immediate left, lines of text flow continuously and repetitively in and out of focus over a transparent three-dimensional surface.

Luminosity

The viewer perceives the text in this sequence as though looking through a glass which stretches, bends, and rotates around the contours of the cylindrical shape. The typeface, rendered into a semi-liquid form with blurred edges and color value shifts, flutters in and out of focus with certain words remaining motionless long enough to be read.

1

1. PROJECT *Untitled Experimental Video* · FORMAT Video · ORIGIN United States
DATE 1998 · DESIGNERS Matthew Pacetti, Christopher Pacetti COMPANY p2
2. PROJECT *Untitled Experimental Video* · FORMAT Video · ORIGIN United States
DATE 1998 · DESIGNERS Matthew Pacetti, Christopher Pacetti COMPANY p2

bu a laine of sweat air

pounding the little elephants

p e shine

li dress her in chain

p swim to live say ik s

li dress her in chain

sism ho r ve say i

shine
p swim to live say ik ts

p ses ho i've stay ts

shine
p swim to live say ik

p ting the little elephants

leave shine
pou swing to live say ints

your tongue
lick right tell to se pink

leave
pounding the little elephants

leave

bu swim to live say air

In this sequence, the text runs on a consistent line. Each phrase overtakes its predecessor as it slowly fades into the viewing frame. The letterforms metamorphosize into one another while an occasional text bite is reinforced through an increased scale that blatantly confronts the reader, or a reduced scale that forces the viewer to look more closely.

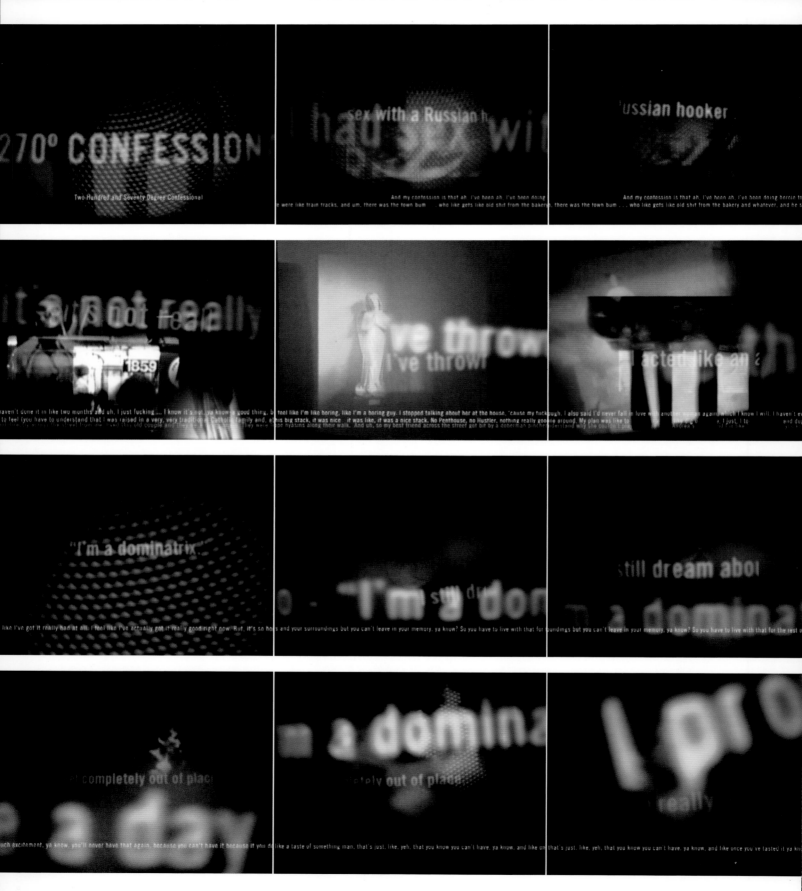

Conjuring Memory

TITLE *270° Confessional* · FORMAT Video · ORIGIN United States · DATE 1997 · DESIGNERS Matthew Pacetti, Christopher Pacetti · COMPANY p2

270° Confessional, a six-minute experimental video, documents the activity of the confessional from the perspective of the listener. Although film and video are considered linear media, *270° Confessional* explores the concept of multiple linearities, functioning at several levels simultaneously.

The type sequence is an exploration of memory, verbal communication, and the visualization of a conscience. Transcriptions of confessions by various individuals are presented in lines of text that scroll from left to right across the bottom of the viewing frame like a stream of consciousness. Shorter phrases emerge from the running text and appear large scale, but semi-transparent above the stream—in a position of greater hierarchy. At an even larger scale, breaking out of the frame are even shorter, and more specific, text bites which reduce each confession to key points. Often, several confessions overlap and create unexpected but humorous juxtapositions of content.

The text activity is layered within dense imagery and set in a darkened atmosphere which transforms the conventional confession booth into a transcendent environment for the reader to experience as voyeur.

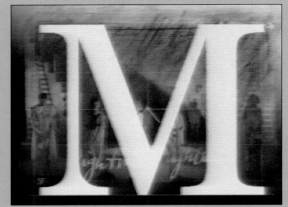

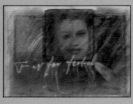

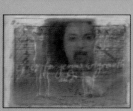

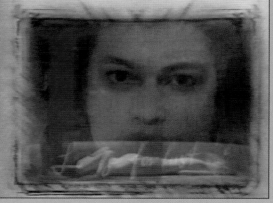
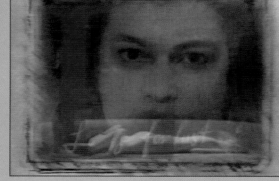

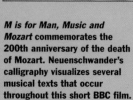

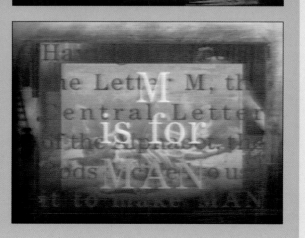

1

M is for Man, Music and Mozart commemorates the 200th anniversary of the death of Mozart. Neuenschwander's calligraphy visualizes several musical texts that occur throughout this short BBC film.

The screen becomes a semi-transparent surface on which gestural marks and hand-rendered letterforms create captions that correspond to the live imagery of the singing actors. The many layers of sung text, read text, and narrative synthesize into compositions that evoke sight, sound and visually tactile sensations. Actors also wear text, handle text, and apply graffiti to the walls of the set.

Peter Greenaway's films create a new visual language in motion by combining film, photography, typography, calligraphy, paintings, and illustration. The use of split screens and frames within frames allows the director to communicate parallel narratives and differences in tense with a densely layered collage of image and text.

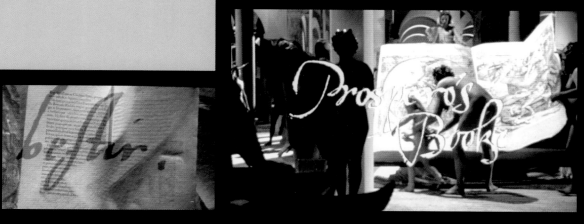

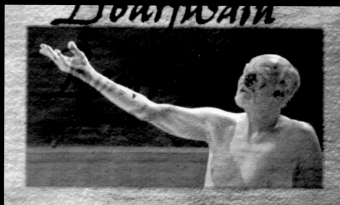

1. TITLE *M is for Man, Music and Mozart* · FORMAT Film for Television · ORIGIN United Kingdom · CLIENT BBC · DATE 1993 · CALLIGRAPHY Brody Neuenschwander · DIRECTOR Peter Greenaway
2. TITLE *Prospero's Books* · FORMAT 35 mm Film ORIGIN United Kingdom · DATE 1991 · CALLIGRAPHY Brody Neuenschwander · DIRECTOR Peter Greenaway

Sight, Sound, and Touch

Brody Neuenschwander is a master lettering artist, graphic designer, and lecturer in calligraphy. He has collaborated with the director Peter Greenaway on several films, including *Prospero's Books*, *The Pillow Book*, and *M is for Man, Music and Mozart*, all of which are filled with literary themes enhanced by graphic, and typographic, symbolism.

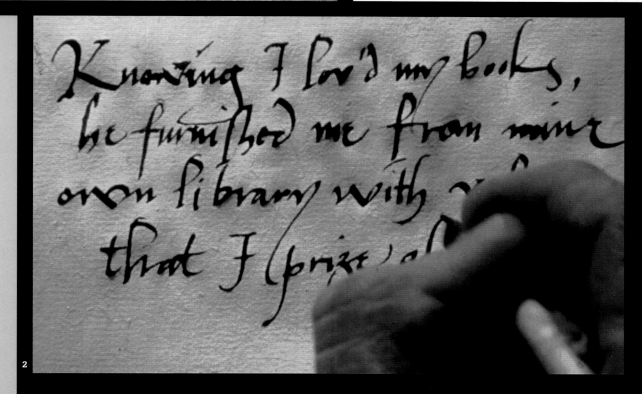

2

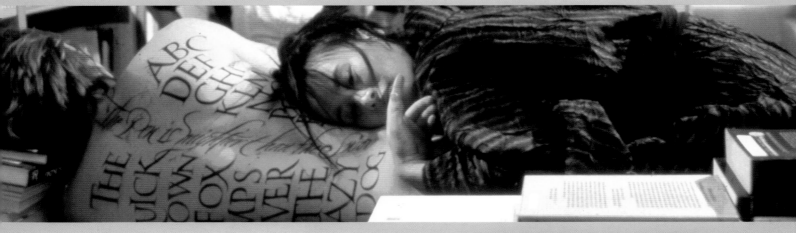

Prospero's Books interprets Shakespeare's *The Tempest* to tell the story of Prospero who writes a play in which he acts and lives. Calligraphy is used here to link Shakespeare's original narrative to a new layer of symbolic language imposed on the work by Greenaway. The relationship of man to knowledge and books is illustrated in scenes viewed through a semi-transparent writing surface. The audience is encouraged to watch, listen, and read as the text and imagery unify into a kinetic, compositional whole.

The art of calligraphy merges erotically with the human body and becomes the central theme in *The Pillow Book*. Greenaway interpreted tenth-century Japanese texts for a twentieth-century story which takes place in Hong Kong and Japan.

Moved by a desire to satisfy her literary drive, a young Japanese woman transcribes her words calligraphically on the bodies of her lovers who become live carriers to her publisher of a series of manuscripts. The body literally becomes an eating, breathing, sleeping, moving book that captures the rapturous relationship between flesh and literature.

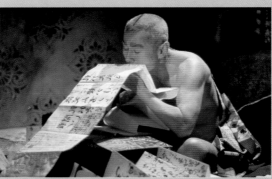

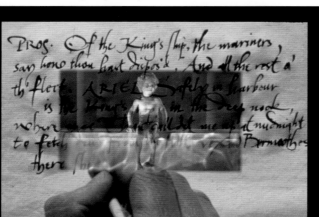

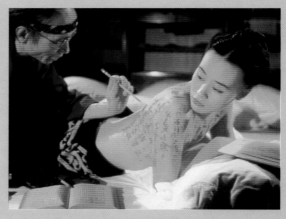

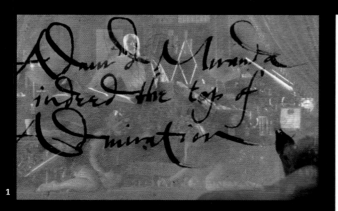

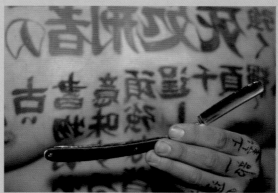

1

2

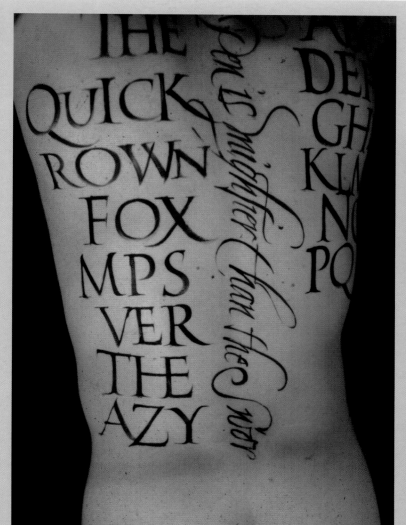

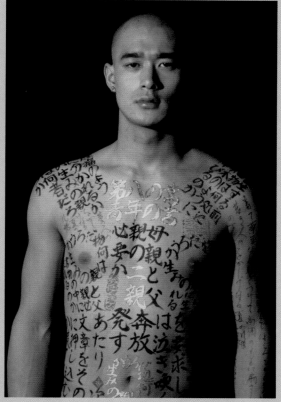

1. TITLE *Prospero's Books*
FORMAT 35mm Film
ORIGIN United Kingdom
DATE 1991
CALLIGRAPHY
Brody Neuenschwander
DIRECTOR Peter Greenaway
2. TITLE *The Pillow Book*
FORMAT 35mm Film
ORIGIN United Kingdom
DATE 1996
CALLIGRAPHY
Brody Neuenschwander and
Yukki Yaura
DIRECTOR Peter Greenaway

In all three of these films Neuenschwander's hand-lettering style was achieved with the use of a broad-nib quill pen, combined with manipulations on a digital-editing system to place them in their designated scenes and sequences.

Neuenschwander rendered letters directly on the skin of the actors for *The Pillow Book*. He used formal Kanji script and Arabic capitals, both sharp and precise in form, to contrast with the irregular contours of the human body. The letterforms twist and stretch in unexpected and often elegant and erotic ways as the bodies move.

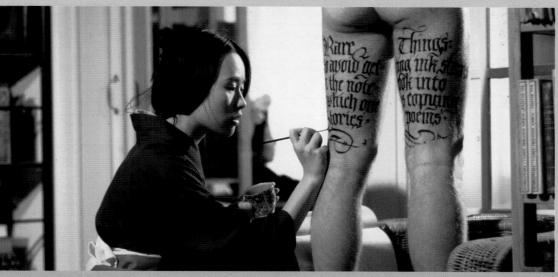

Body Text

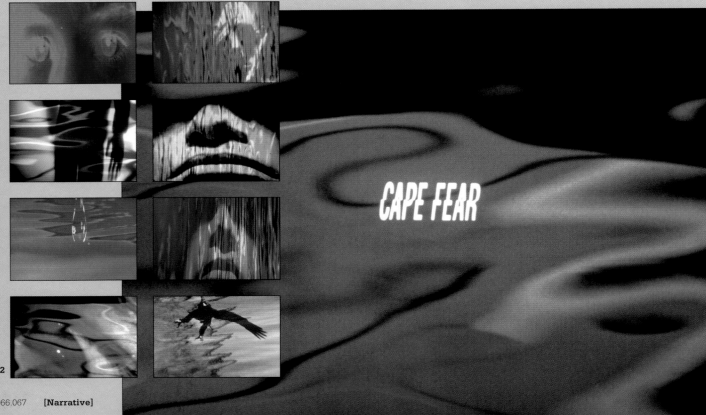

[Narrative]

Abstraction

The fast-paced life of mobsters is simulated in the opening for *Goodfellas.* The title treatment, set in the typeface Helvetica and colored bright red, zooms horizontally into the frame, pauses just long enough to be seen, and then zips away as fast as it came.

The opening title sequence for *Cape Fear* is minimal, but resonant. The title and credits are set in a bold, oblique, condensed typeface, reversed out over a myriad of layered images, including water, dripping blood, and grotesque distortions of the killer's face. A very subtle distortion of the title embraces Bass's reductive, but highly effective, approach to time-based typography.

The opening sequence to *The Age of Innocence* uses time-elapsed footage of blossoming roses overlaid by lines of elegant script lettering to create a textured background and establish the historic context of the film.

1. TITLE *Goodfellas* · FORMAT 35 mm Film · ORIGIN United States · DATE 1990 · DESIGNERS Saul and Elaine Bass · DIRECTOR Martin Scorsese · PRODUCER Irwin Winkler · ©1990 Warner Bros. Inc.

2. TITLE *Cape Fear* · FORMAT 35 mm Film · ORIGIN United States · DATE 1991 · DESIGNERS Saul and Elaine Bass · DIRECTOR Martin Scorsese · PRODUCER Barbara De Fina · COMPANY Cappa Films and Tribeca Productions ©1991 Universal City Studios, Inc. · Amblin Entertainment

3. TITLE *The Age of Innocence* · FORMAT 35 mm Film ORIGIN United States · DATE 1993 · DESIGNERS Saul and Elaine Bass · DIRECTOR Martin Scorsese · PRODUCER Barbara De Fina · ©1993 Columbia Pictures Industries, Inc.

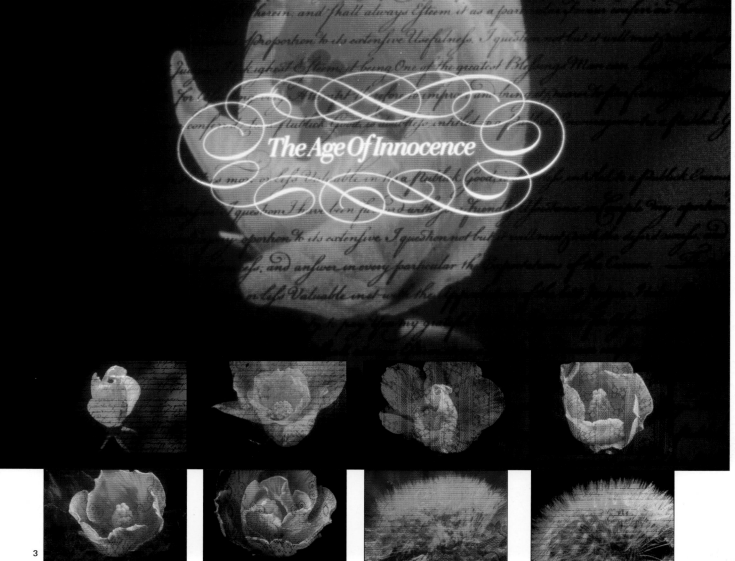

First Words

Balsmeyer & Everett, Inc. is a New York-based design firm specializing in film-title sequences. Randy Balsmeyer advocates a close director–designer relationship in the creative process so that the title sequence appropriately reflects the director's theme.

Ransom's storyline revolves around the kidnapping of a child and the subsequent search for clues by the distraught parents. The opening title treatment of the film imitates the search through the use of a graphic metaphor—the counters of the heavy sans serif letterforms are slowly revealed one by one until the title is complete, dropped out of a red rectangle, thus revealing the imagery. The counterform reverses to end the title sequence.

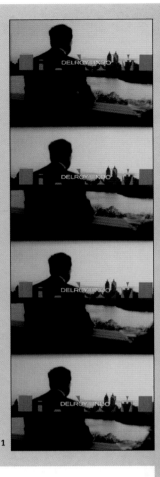

1

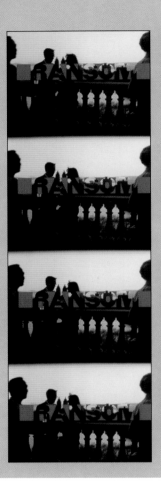

Short Cuts is a film based on a collection of short stories written by Raymond Carver. The premise of the film centers around the lives of several characters, whose separate stories become interconnected by the end of the film.

The unrefined quality of the letterforms of the title break and reconnect, as if cut with scissors, reflecting the storyline. The remaining credits flicker and float in front of images of helicopters spraying medfly poison over California and the lives of the interconnected characters.

2

The imagery of the title sequence of *Waiting to Exhale* appears to be ocean waves at night, but as the sequence progresses the color changes from night to day and the ocean changes to sand dunes. The main title travels over these dunes and breaks into a sandstorm of tiny particles as it approaches the frame and increases in scale.

3

The Big Lewbowski opens like an old western with the camera following a token tumbleweed across the desert. However, this rambling brush is, in fact, traveling down the streets and beaches of contemporary Los Angeles. The West Coast cultural journey ends in a bowling alley, where the story of Lebowski, a.k.a. "Dude", begins.

Bureau was challenged to design a title treatment that successfully combines the mythic qualities of an old western with the urban kitsch of bowling. They accomplished this by forcing the odd marriage of the typefaces Ponderosa, activated with a wood texture, and Magneto, sporting a chrome finish. The entire title animation simulates the actions of a bowling pinsetter, which in turn sets the opening scene of the film.

4

5

A man's descent from his normal and predictable life into chaos and, ultimately death, is the premise for Jim Jarmusch's film *Dead Man*. The opening sequence follows the main character on a train traveling from civilization in the East to the Wild West. The opening credits emulate the train, zooming toward and past the frame. The title

treatment takes an illustrative approach, utilizing bones for letterforms. The title slowly zooms out, the letterforms exploding and disintegrating in the process.

1. TITLE *Ransom* · FORMAT 35 mm Film · ORIGIN United States · CLIENT Touchstone Pictures · DATE 1996 · DESIGNER Randy Balsmeyer · DIRECTOR Ron Howard · EDITORS Dan Hanley, Mike Hill · COMPANY Balsmeyer & Everett, Inc.
2. TITLE *Short Cuts* · FORMAT 35 mm Film · ORIGIN United States · CLIENT Fine Line Features · DATE 1993 · DESIGNER Randy Balsmeyer · DIRECTOR Robert Altman · 3D ANIMATION Michael Arias · EDITOR Geraldine Peroni · COMPANY Balsmeyer & Everett, Inc.
3. TITLE *Waiting to Exhale* · FORMAT 35 mm Film · ORIGIN United States · CLIENT 20th Century Fox · DATE 1995 · DESIGNER Randy Balsmeyer · DIRECTOR Forest Whitaker · GRAPHIC DESIGN Jennifer Bernstein · DIGITAL ANIMATION Daniel Leung · EDITOR Richard Chew · COMPANY Balsmeyer & Everett, Inc.
4. TITLE *The Big Lebowski* · FORMAT 35 mm Film · ORIGIN United States · CLIENT PolyGram Filmed Entertainment · DATE 1998 · DESIGNER Randy Balsmeyer · DIRECTOR Joel Coen · PRODUCER Ethan Coen · DIGITAL ANIMATION Matt McDonald (main title card), Amit Sethi (Gutterballs) · DIGITAL COMPOSITING Daniel Leung · EDITORIAL/GRAPHICS Gray Miller · COMPANY Balsmeyer & Everett, Inc.
5. TITLE *Dead Man* · FORMAT 35 mm Film (black & white) · ORIGIN United States · CLIENT 12-Gauge Productions, Inc. · DATE 1995 · DESIGNER Randy Balsmeyer · DIRECTOR Jim Jarmusch · GRAPHIC DESIGN Jennifer Bernstein · EDITOR Jay Rabinowitz · COMPANY Balsmeyer & Everett, Inc.

Rotation and Spin

Un balanced was her load is an installation from a thesis show which uses the cycles of a washing machine as a metaphor for the internal agitation experienced by a person positioned as a fictitious other. Two voices, the subjective (the woman coping with the many voices demanding her attention) and the objective (historical commentary on the woman's role as the handler of other peoples' dirty garments) express the internal agitation experienced by the subject in three cycles—agitation, rinse, and spin.

This work is a critique of domesticity, the historical position of people who clean, and the psychological impediments that govern how we move through the world. The use of appropriated logos and "retail" typefaces support the theme as the words of the sequence are sent through the washing process.

The installation consists of the sequence played on a video monitor placed inside a top-loading washing machine. The viewer is invited to look inside the washer and reflect on the dirty laundry as it goes through three cycles.

1

Motion and Typography is a single semester course at the California Institute of the Arts that addresses the role of time in the design of movie titles. The first half of the semester explores ideas of signification through typographic form and motion; narrative; pace; and storyboard concepts. The second half of the semester involves the creation of a 30-second title sequence for a film. The students choose their own films and are encouraged to generate their own imagery with typography.

2

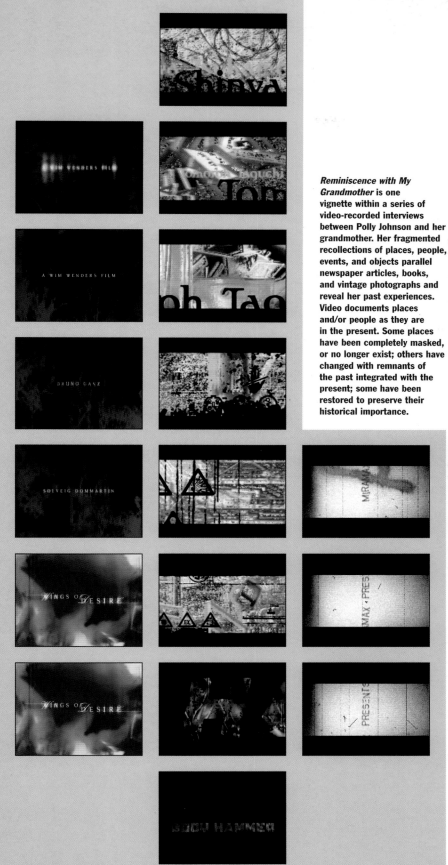

1. TITLE *Un balanced was her load* · FORMAT Video · ORIGIN United States · DATE 1996 · INSTRUCTORS Katherine McCoy, Andrew Blauvelt · DESIGNER Ziddi Msangi · UNIVERSITY Cranbrook Academy of Art
2. TITLE *Film Title Design* · FORMAT Digital Media · ORIGIN United States · DATE 1997 · INSTRUCTOR Michael Worthington · DESIGNERS Pat Dinkfield, Hwee Min Loi, Lee Schultz, Jamandru Reynolds, Bucky Fukomoto · UNIVERSITY California Institute of the Arts
3. TITLE *Reminiscence with My Grandmother* · FORMAT Video · ORIGIN United States · DATE 1997–98 · DESIGNER Polly Johnson

Reminiscence with My Grandmother is one vignette within a series of video-recorded interviews between Polly Johnson and her grandmother. Her fragmented recollections of places, people, events, and objects parallel newspaper articles, books, and vintage photographs and reveal her past experiences. Video documents places and/or people as they are in the present. Some places have been completely masked, or no longer exist; others have changed with remnants of the past integrated with the present; some have been restored to preserve their historical importance.

Interviews with her friends and family fill in gaps that she cannot remember, contradict her stories, or add their unique perspective to her recollections.

The typography for this sequence functions at several levels. Type substitutes the interviewer's (author's) voice—because the author's grandmother is deaf, the absence of an audible voice seems appropriate. Type communicates additional information to support and add to her narrative. Moving typography emphasizes points within texts. Vernacular typography from found material and environments, such as menu boards, signage and newspaper articles, helps create a sense of place.

Evoking the Past

Symbols and Icons

3

THE RED

Il Violino

Le Violo

THE RED VIOLIN

THE RED VIOLIN

Multi-lingualism

Toronto-based designer Bruce Mau, along with his
studio Bruce Mau Design, is internationally known
for his designs for *Zone Books* and his collaboration
with the architect Rem Koolhaas on *S,M,L,XL*
(Monacelli Press, 1995). *The Red Violin* is Mau's
first film-title design.

Rosso

VIOLIN

te Geige

n Rouge

THE RED VIOLIN
Le Violon Rouge
Il Violino Rosso
红提琴
Die Rote Geige

THE RED VIOLIN
Le Violon Rouge
Il Violino Rosso
红提琴
Die Rote Geige

TITLE *The Red Violin*
FORMAT 35 mm Film
ORIGIN Canada · CLIENT
Rhombus Media · DATE 1998
DESIGNERS Bruce Mau
with Christopher Pommer
COMPANY Bruce Mau Design

The opening sequence, a long lyrical pan through an Italian craftsman's workshop, led the designers to choose News Gothic, a clean and contemporary typeface, because they thought its "simple contours would amplify the rich movement of the sound and image."

The title treatment is a delicate balance between the English translation, set in white News Gothic, and the various other languages in historically reminiscent typefaces that it overlays. The background text creates a textural field of floating crimson, on which the title rests, connecting the violin's history with its future.

The film covers an enormous span of time, and several countries and languages. The title sequence is an elegant solution, successfully suggesting a range of historical periods and cultural values, without forfeiting the communicative function.

The film *The Red Violin* traces the life of a violin across five continents and three centuries, beginning with its creation during the golden age in Cremona, Italy, and ending in present-day Montréal. The narrative is episodic, literally and metaphorically connecting the stories of the various characters who have owned the violin in Vienna, London, and Shanghai.

Optical Illusion

Pablo Ferro has been a pioneer in the advancement of new developments in film technology, such as video-based optical effects, to free typography from its once static, flat, and frontal role in opening sequences.

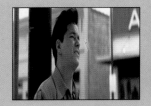

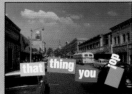

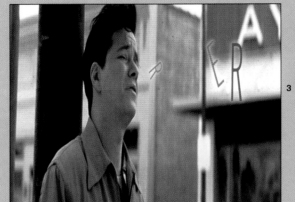

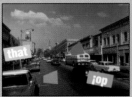

Simple, white, sans serif letters matched with whimsically colorful shapes bounce onto the screen, dance around and then assemble to spell *That Thing You Do!* **in this title sequence.**

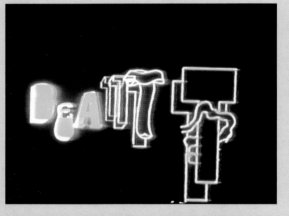

The letterforms possess the colors, three-dimensionality, and vibrancy of neon lights as they rush onto the screen and assemble themselves with the energy of a rock-and-roll band to spell *Beatlemania: the Movie* **in this film trailer.**

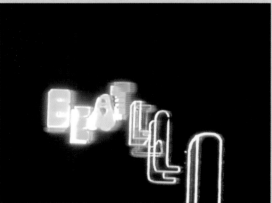

BEATLEMANIA: THE MOVIE

Letterforms fly out of the mouth of this character as he speaks during the opening sequence of the film *Career Opportunities.*

The title sequence for *Good Will Hunting* takes advantage of computer technology to create a mesmerizing, hyper-layered, translucent mosaic of books, notes, and mathematical formulae that absorb and expel the title and credits.

The title treatment and credit information are set in a simple sans serif typeface in order to hold legibility as they venture into the complex, scholarly space that captures the troubled genius of the main character, Will Hunting.

4

1. TITLE *Beatlemania: the Movie* · FORMAT 35 mm Film · ORIGIN United States · CLIENT American Cinema · DATE 1980 DIRECTOR and DESIGNER Pablo Ferro · COMPANY Pablo Ferro

2. TITLE *Career Opportunities* · FORMAT 35 mm Film · ORIGIN United States · CLIENT MCA/Universal Pictures · DATE 1991 TITLE DESIGNER Pablo Ferro · DIRECTOR Bryan Gordon · COMPANY Pablo Ferro & Associates

3. TITLE *That Thing You Do!* · FORMAT 35 mm Film · ORIGIN United States · CLIENT Twentieth Century Fox · DATE 1996 TITLE DESIGNER Pablo Ferro · DIRECTOR Tom Hanks · COMPANY Pablo Ferro & Associates

4. TITLE *Good Will Hunting* · FORMAT 35 mm Film · ORIGIN United States · CLIENT Miramax · DATE 1998 · TITLE DESIGNER Pablo Ferro · TITLE SEQUENCE Pablo Ferro · DIRECTOR Gus Van Sant · COMPANY De Pablo Productions

Simple, elegant script lettering is rendered over a dreamy backdrop of imagery in this opening sequence for *Leo Tolstoy's Anna Karenina*.

Scripted, Zoomed, and Liquefied Words

Macro–micro relationships are exploited in a playful manner in this title sequence for a remake of the classic *Doctor Dolittle*. The title and credits emerge set in a small, white sans serif typeface on a black background. As the words move closer to the viewer and increase in size, the viewer learns that the letters are actually constructed of carefully posed, yet highly expressive animals.

2

1

The credits and title treatment for *Hope Floats* emerge in a liquid state and solidify into legibility as if bubbling up to the surface from the live backdrop imagery.

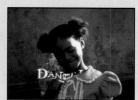

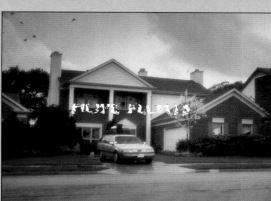

1. TITLE *Leo Tolstoy's Anna Karenina* · FORMAT 35 mm Film · ORIGIN United States · CLIENT Icon Pictures/Warner Bros. DATE 1998 · TITLE DESIGNER Pablo Ferro · DIRECTOR Bernard Rose · COMPANY De Pablo Productions

2. TITLE *Doctor Dolittle* · FORMAT 35 mm Film · ORIGIN United States · CLIENT Twentieth Century Fox · DATE 1998 · TITLE DESIGNER Pablo Ferro · DIRECTOR Betty Thomas · GRAPHIC ASSISTANT Joe Gornik · COMPANY De Pablo Productions

3. TITLE *Hope Floats* · FORMAT 35 mm Film · ORIGIN United States · CLIENT Twentieth Century Fox · DATE 1998 · TITLE DESIGNER Pablo Ferro · DIRECTOR Forest Whitaker · COMPANY De Pablo Productions

4. TITLE *Dance with Me* · FORMAT 35 mm Film · ORIGIN United States · CLIENT Mandalay Entertainment · DATE 1998 · DIRECTOR Randa Haines · TITLE SEQUENCE Pablo Ferro with Harold Adler · COMPANY De Pablo Productions

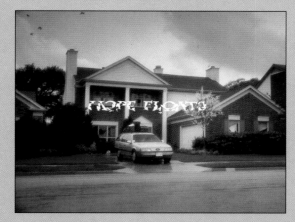

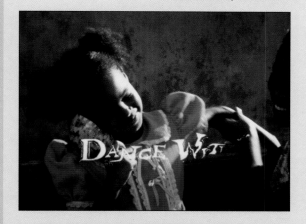

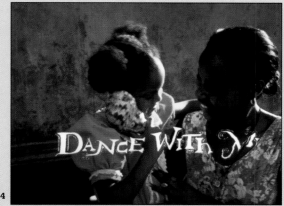

Ferro collaborated with the master lettering artist Harold Adler to create the wood-cut quality title treatment and opening sequence for *Dance with Me*. Adler, considered the father of title design, paved the way for Pablo Ferro and Saul Bass, and, in turn, directly (and indirectly) influenced a growing number of young title designers today.

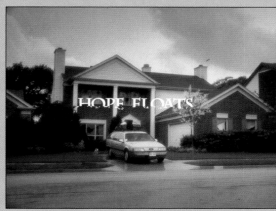

4

3

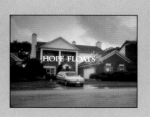

3 [Message]

The advertising industry has harnessed the power of the letterform to deliver market-specific messages to viewing audiences. This chapter considers the role of kinetic typography in message-making. Digital technologies allow the letterform to assume poetic qualities in sequences that must deliver volumes of information in a limited period of time.

OSTEOPOROSIS

BODY

afflicting
WOMEN
80%

AFFLICT *over*

1,000,000

WOMEN

A YEAR

BRITTLE

CALL 1-888-62-WOMEN

Romancing the Type

Jon Barnbrook is a titles director for Tony Kaye Films in London. The innovative British designer satisfies his thirst for type design with his foundry known as Virus. Barnbrook pursues a continuing romance with typography by embracing the image of the letterform to enhance the meaning of the word in which it is used, often employing his design as a personal platform.

The sequence for *Vick's* medication uses an assortment of lines, brackets, circles, and boxes to link the type and image elements in an ethereal, diagrammatic manner that simulates the relief that the product can bring to the cold sufferer. Each frame is a composition in itself with an amorphous background that contrasts with carefully composed typographic elements to establish a sense of depth. Each word is set in a typeface that visually enhances its meaning: the typeface used for swollen tissues actually swells, while the letters in the word stuffy squish together before they separate in relief.

In the sequence for the Borgess Health Alliance, letterforms slowly dissolve in and out of a background of human x-rays and other images of microscopic organisms. This television spot, which warns women of the dangers of Osteoporosis and offers information on prevention, is a departure from the health information vehicle that usually displays unadorned text in a cold matter-of-fact manner or attempts a human approach with a couple walking on a beach. The soft image quality and warm color palette of Barnbrook's sequence makes it attractive while delivering its serious message.

The typography is sequenced to a voiceover narration; not word-for-word, but in bites. Barnbrook uses an "O" centered in the viewing frame to establish a compositional focal point. This graphic constant assumes the roles of image and letter as key points made by the narrative emerge into view.

2

This sequence for Koan Fashions uses elegant footage of closely cropped and abstracted fabric textures and organic elements. The edges of the white typographic forms are softened to create a sense of atmosphere over the gray-scale imagery. The letters move just enough to attract attention and serve as the focal point in each frame composition.

3

1. TITLE *Osteoporosis Television Spot* · FORMAT Video · ORIGIN United States · CLIENT Borgess Health Alliance · DATE 1997 · DESIGNER Jonathan Barnbrook · AGENCY Traver Rohrback Advertising · ART DIRECTORS Scott Osborne, Tracey Ellenberg · COPYWRITER Bill Hann EDITOR Keiron Walsh, Manhattan Transfer · COMPANY Tony Kaye & Partners

2. TITLE *Vicks Television Spot* · FORMAT Video · ORIGIN United Kingdom · CLIENT Procter & Gamble · DATE 1996 · DESIGNER Jonathan Barnbrook · AGENCY Leo Burnett · ART DIRECTOR Stuart Newman · COPYWRITER Julian Borra · EDITOR Jon Hollis, Smoke & Mirrors · COMPANY Tony Kaye & Partners

3. TITLE *Koan Television Spot* · FORMAT 35 mm film · ORIGIN Italy · CLIENT Koan Fashions DATE 1996 · DESIGNER Jonathan Barnbrook · AGENCY McCann Erickson · ART DIRECTOR Roxanne Bianco · COPYWRITER Alexando Canale · EDITOR Dave Smith, The Mill · DIRECTOR OF PHOTOGRAPHY Julian Court · COMPANY Tony Kaye & Partners

This *BBC Radio Scotland* advertisement prompts the viewer to "rediscover the power of the spoken word." Barnbrook seizes the opportunity to merge this thought with the power of the *visible* word in this sequence assembled from beautifully composed frames of type and image, most of which are hand crafted. Spelling out word and think using lead-press type, and then re-composing the word think to emphasize ink are subtle and clever interjections.

This quick-edit, staccato sequence is a series of slightly animated static compositions. Layers of fractured and sometimes heavily manipulated letterforms with improper behaviors—the vertical type moving from the top to the bottom of the frame cannot be read—seem to rejoice in flirting with their own legibility.

TITLE BBC Radio Scotland Television Spot · FORMAT 35 mm Film, Video · ORIGIN Scotland · CLIENT BBC Radio Scotland · DATE 1995 · DESIGNER Jonathan Barnbrook AGENCY Faulds Advertising · ART DIRECTOR Adrian Jeffrey · COPYWRITER David Reid · EDITOR Jon Hollis, The Mill · COMPANY Tony Kaye & Partners

Recycled Characters

Phosphorescence

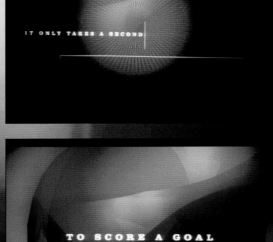

Nothing is new except arrangement—Will Durant.

This aphorism and a collection of others provide the content for the sequence entitled, *35 Years of Design and Art Direction*, commissioned for the 35th anniversary of the company by the same name. The sequence begins with three crosses pulsating and glowing. These characters are actually the letter T in Barnbrook's typeface *Exocet*. This is followed by other soft-edged, geometric, and organic shapes that float in an environment of fluctuating light and multiple hues. The softness of the typography, as it dissolves in and out and slowly moves across the frame, evokes an emotional appeal to the content.

1

Velocity and Direction

This type sequence for the Design Centre digital portfolio at Wanganui Polytechnic School of Art and Design, New Zealand, uses a moving road with its passing lines as background texture for descriptive text advertising the Centre. Rather than animating the typography using a computer, type treatments were printed on paper and then digitized directly to a computer through a video camera.

The movement of the type was established by moving the printouts as the camera captured the image. The resulting type sequence was then composited onto the road footage to add further movement and texture to the presentation.

Breathing Backwards is a three-minute conceptual video that speaks about the inherent connection that prevails through all things in a world which has been fragmented, displaced, and seemingly disillusioned.

It is about attempting to breathe backwards, metaphorically, to try to exist in a different way and to challenge one to live more, be more, feel more.

This sequence responds to the question of contemporary identity by asking "where" instead of the more important question "when" we find ourselves—in what moments do we connect—which is more appropriate because the nature of "being" in the world today is increasingly becoming more temporal through technology.

1. TITLE 35 Years of Design and Art Direction · FORMAT Video · ORIGIN United Kingdom · CLIENT D+AD · DATE 1997 · DESIGNER Jonathan Barnbrook · EDITOR Jon Hollis, Smoke & Mirrors · COMPANY Jonathan Barnbrook

2. TITLE Design Centre · FORMAT Digital Media · ORIGIN New Zealand · CLIENT Design Centre · DATE 1995 · DESIGNER Jeff Bellantoni/-ization

3. TITLE Breathing Backwards · FORMAT Video · ORIGIN United States · DATE 1997 · DESIGNER Kathryn Marsan · UNIVERSITY Cranbrook Academy

2

3

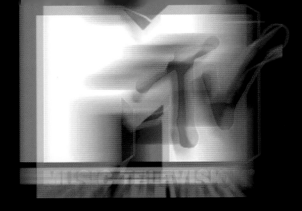

1

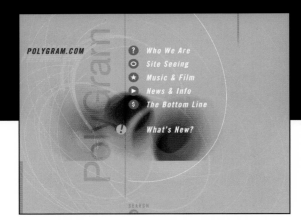

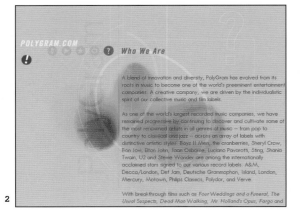

2

Reinventing the Logo

The time-based commercial work of the studio design p2 represents a successful evocation of contemporary design driven by a carefully considered blend of digital technology and an assortment of more traditional materials, methods, and media. The typography is dynamic and elegant, and although sometimes densely layered, never loses sight of its function— to communicate effectively to, and visually stimulate, its intended audience.

(1) The interface of the p2 promotional CD-ROM greets the user with a sample of their deeply exploratory visual syntheses.

(2) p2 applied a refined version of their motion-influenced gestural style to the web site for Polygram Records.

(3) Four stills from the *MTV Station Identity Animations* capture the electricity of the pop music channel. p2 has developed a hand-wrought, gestural style that synthesizes well with technologically rendered typography. Even frozen on the page, a treatment of the MTV logo gives the sensation of it being swallowed by a turbulent tornado constructed from a black-and-white circular pattern of lines of variable width.

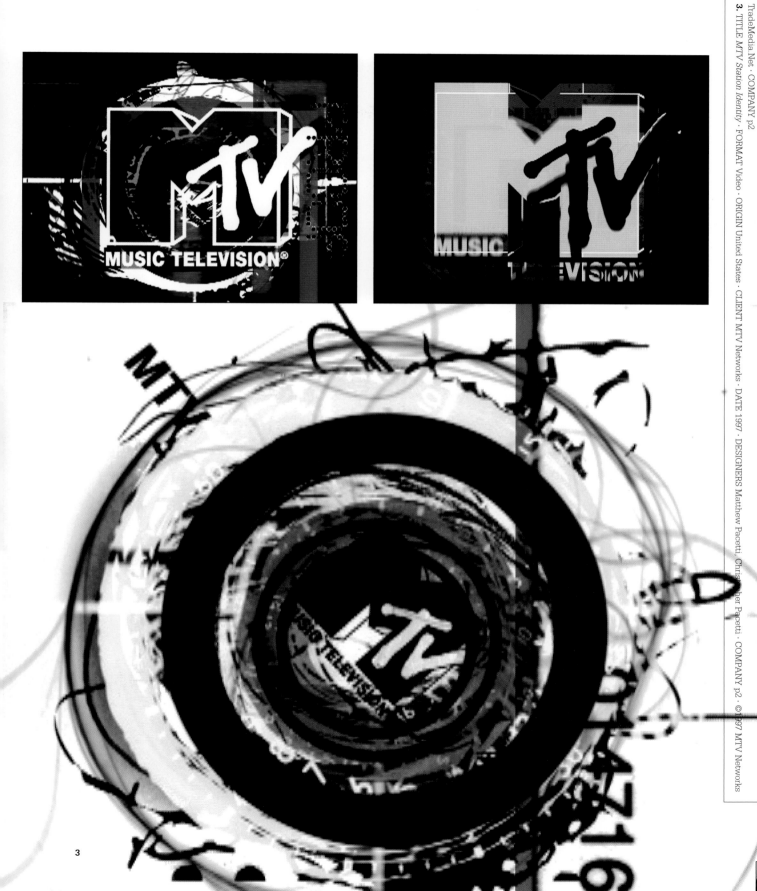

1. TITLE *p2 1990-96 Variations Electronic Portfolio* · FORMAT Digital Media · ORIGIN United States · DATE 1996 · DESIGNERS Matthew Pacetti, Christopher Pacetti · COMPANY p2

2. TITLE *Polygram.com Website* · FORMAT Digital Media · ORIGIN United States · CLIENT Polygram Corporate · DATE 1996 · DESIGNERS Matthew Pacetti, Christopher Pacetti · PROGRAMMING TradeMedia.Net · COMPANY p2

3. TITLE *MTV Station Identity* · FORMAT Video · ORIGIN United States · CLIENT MTV Networks · DATE 1997 · DESIGNERS Matthew Pacetti, Christopher Pacetti · COMPANY p2 · ©1997 MTV Networks

Fusion and Fission

Sonya Mead and Margaret Jacobi used animated typography in the design of promotional videos while at Fitch, Inc., an international design firm located in Boston specializing in research-based product design and development, branding, and environments.

Gamescape is an animated sequence that conveys the creative visions, expert solutions, and global strategies in the gaming world of GTech.

The *Gamescape* logo emerges as two blurred sections from the front and rear of the

viewing frame, coming into focus as they connect. The horizontal curvilinear bisection of the logo resembles a mountain range, and magenta text: "The thinking of positive power", establishes a horizon line.

The horizon text then assumes a curved path that multiplies and rotates toward the center of the screen and becomes out of focus as an image of a brain fades in to replace the logo.

1

2

1. TITLE *Gamescape* · FORMAT Video · ORIGIN United States · CLIENT GTech · DATE 1996 · DESIGNERS Sonya Mead, Margaret Jacobi, Gideon Ansell · PROGRAMMER Peter Newbery · COMPANY Fitch, Inc.
2. TITLE *MoCCA (Mobile Communication and Computing Architecture)* · FORMAT Video · ORIGIN United States · CLIENT Digital · DATE 1997 · DESIGNERS Sonya Mead, Margaret Jacobi, Kyle Hoyt · MUSIC Gideon Ansell · COMPANY Fitch, Inc.

The spiral theme continues as a gyroscope replaces the brain along with the text, "minds to the matter". The screen then divides into six sections to accommodate key words about the goals of GTech.

These words quickly change position and typeface and eventually merge toward the center of the screen, increasing in scale as they move toward the viewer until they become completely out of focus.

MoCCA (Mobile Communication and Computing Architecture) is a conceptual product which aids the service employees of Digital, a Boston-based computer company, while they are working away from the office. MoCCA is a three-inch-square communications device which can be worn and allows multiple calls, video conferencing, voice activation, data archival, searches and web access, scheduling, mapping, diagnostics, and has many other features.

The stills on these pages represent the sequence which was used in the promotion of MoCCA. The typeface in the logo identity is constructed of simple lines. The complex hairlines of the MoCCA technical drawing contrast just enough with the heavier weight of the typeface to establish a depth while the two elements fuse into one image in motion.

The product and interface won an IDEA Gold 1998 award.

2nd Sight is a film that promotes the release of the book by the same name on the work of David Carson, a designer widely known for "breaking the rules" by introducing an *illegible* legibility and process-oriented approach to the discipline of graphic design. This film makes no exception to what has become Carson's signature style.

PROCESS

Subversion

1

Type-space and Beyond

In addition to many years of designing precedent-setting and memorable film titles, R/Greenberg Associates also create technologically superior advertisements and promotionals for broadcast television.

1. TITLE *2nd Sight* · FORMAT Film · ORIGIN United States DATE 1997 · A FILM BY John DiRe, Antoine Tinguely, Jakob Trollbeck · CONCEPT David Carson · LINE PRODUCER Melissa August · MUSIC Elias Associates · AUDIO MIX Jakob Trollbeck · EDITOR Brendan Werner · COMPANY R/Greenberg Associates · ©1997
2. TITLE *Dodge Television Campaign* · FORMAT Video ORIGIN United States · DATE 1998 · DESIGNER R/Greenberg Associates · COMPANY R/Greenberg Associates

This sequence, inspired by Carson's concept, is not designed to flow smoothly or carry a single message, but rather leave the viewer with thought-bites on *emotion, intuition*, and *process* as they apply to design and communication. This is accomplished with quick edits and erratic flashes of quotes and phrases on the screen. Most of the typography was captured as it was rendered on the screen of a video monitor, then fractured, over-exposed, blurred, and colorized to evoke a kinetic, textural, and atmospheric quality.

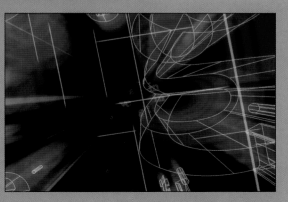

Three opening sequences to television spots for new Dodge products all begin with the same text treatment: "We're changing everything. Again"— set in the typeface Garamond and arranged in the traditional center of the viewing frame, white on black. But just as the viewer has had time to read this phrase, the words suddenly break apart and the letters zoom at the speed of light toward the viewer's eyes.

The *Lifetime Television* station identification spots (1987) were initially shot using a hand-held camera with 8mm film and manipulated using a Quantel Video and Graphic Paintbox, considered high-tech at the time. Greiman referred to this technology as "visual mixing valves" because of the liquid-like state of a digital representation. The visible patterns in these examples are the result of the open weave of the video raster; horizontal scan lines that produce the image on a cathode-ray tube monitor. Set against this is a square that contains the bold blocky L of the Lifetime logo. The square creates a subzone and a compositional focal point within the viewing frame. This zone utilizes layering and variable opacities of technical elements such as reception static and the color-bar test pattern used in the broadcast industry to allow the logo to emerge subtly from its fluid background.

1

Pixelism

April Greiman, principal of Greimanski Labs and design educator, embraced the desk-top computer with a vengeance in the early 1980s and developed a signature style that exploited the resolution limitations of early desk-top digital technology on a molecular level by elevating the bit-map patterns of square pixels as formal, structural, and spatial design elements.

1. TITLE *Lifetime Television* identification spots · FORMAT Video · ORIGIN United States · CLIENT Lifetime Television · DATE 1987 · DESIGNER April Greiman · COMPANY Greimanski Labs
2. TITLE *Lux Pictures, website splash page animation* · FORMAT Digital Media · ORIGIN United States CLIENT Lux · DATE 1997 · DESIGNER April Greiman · COMPANY Greimanski Labs

2

This splash page animation for the *Lux Pictures* website was created ten years after the *Lifetime* spots, but Greiman's approach still displays the unique visual characteristics found at the micro level of digital technology.

Video raster lines combine with geometric shapes to create a textured background environment from which simplified letterform constructions of large squares come forward. These rudimentary, bitmapped

letters then transform into their true likenesses as they come together to spell the name Lux Pictures.

DARKNESS

BOUNDING US

WE FLOA

THEN

IN TIME

GRAVITATION

SENS

&

E GHOST EARTH

NOR ANY SOUND

FLOAT

SPACE OF SOUL

NOR ANY SOUNDS

1

1. PROJECT *Type in Motion Class Assignment* · FORMAT 16 mm Film, Video · ORIGIN New Zealand · DATE 1996 · UNIVERSITY Wanganui Polytechnic School of Art and Design · INSTRUCTOR Jeff Bellantoni · DESIGNER Hishamuddin Saruwi
2. PROJECT *Type in Motion Class Assignment* · FORMAT Video · ORIGIN United States · DATE 1997 · INSTRUCTOR Jeff Bellantoni · DESIGNER Laurie Sheets · UNIVERSITY Virginia Commonwealth University

We must

must resist

the temptation

replicate ourselves

we do it all the time.

blood transfusions
chemotherapy

...THE Pill

which of the world's children will have the

ren

nde

rin

ing

it isn't God
means to survive.
survive

God
G o

100

of other categories of GOD'S creatures

Go

God
od

Extinct.

Extinct.

The sequences presented here represent two solutions using different technological approaches to assigned student projects on *Type in Motion* courses.

Utilizing a more traditional hands-on method, the poetic text of the sequence on the opposite page is enhanced through the use of background textures which were created by scratching directly onto 16 mm film. The text was printed and then filmed directly into a camera. The simple but effective flat, two-dimensional movement is created by quickly moving the paper for the camera to capture.

The sequence on this page uses digitally generated and manipulated letterforms to communicate the content of an otherwise straightforward newspaper article. Set in lighter values of gray, the oblique sans serif letterforms sequentially dissolve into the parent font, spelling out the words for the viewer to read on the screen. This revealing treatment of the word "rendering" is especially effective

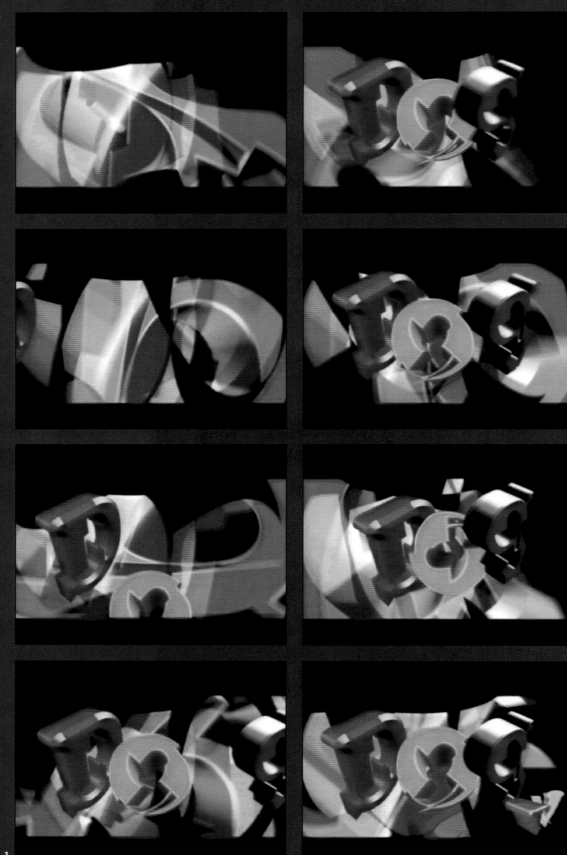

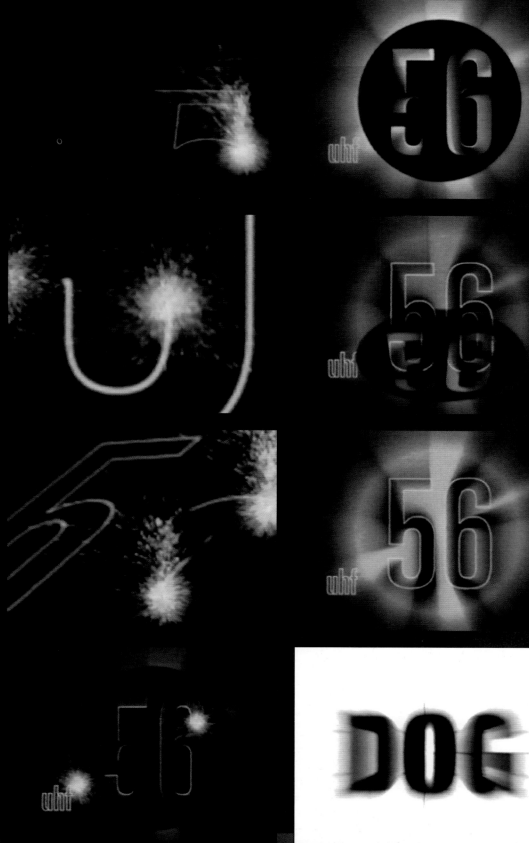

1. TITLE *dogtv Station Identity* · FORMAT Video
ORIGIN New Zealand · CLIENT dogtv, UHF 56 · DATE 1996
INSTRUCTOR Jeff Bellantoni · DESIGNER Joel Inteman
UNIVERSITY Wanganui Polytechnic School of Art & Design
2. TITLE *dogtv Station Identity* · FORMAT Video · ORIGIN
New Zealand · CLIENT dogtv, UHF 56 · DATE 1996
INSTRUCTOR Jeff Bellantoni · DESIGNER Carl Bolter
UNIVERSITY Wanganui Polytechnic School of Art & Design

These ten-second broadcast identity spots were designed by students for *dogtv, UHF 56*, a music television station based in New Zealand.

In the sequence on the opposite page, the letters of the word "dog" move into the frame and rotate independently of each other. The grunge-like typeface is given an additional stylistic effect by modeling the letterforms in three dimensions. These fascinating, but still legible, letterforms spin in front of waves of color, creating a psychedelic effect.

The sequence on this page uses digital technology to create the burnt-out effect of the bold letterforms "56" which fall forward to reveal a strong light source from behind. The light bursts through the outlined "56" and transforms it into the word "dog".

2

Seeing the Light

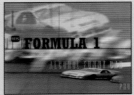
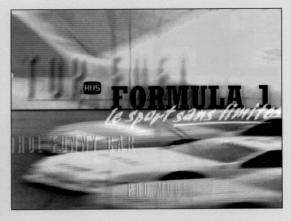

This hyperactive graphic identity proposal for the *RDS Sports* channel uses a formal structure within the viewing frame, similar to a printed-page layout. The screen is split either vertically or horizontally into sub-zones that contain video insets and text matter. Hierarchy is established through the use of the static, bold slab-serif typeface for the titles in contrast to a quickly rendered brush script that spells *sans*, to highlight the phrase, "le sport sans limites" (the sport without limits.) Supporting the main titles are semi-transparent buzzwords that effectively synthesize text, in content and form, with image by mimicking the motion of the image elements to generate a feeling of high energy.

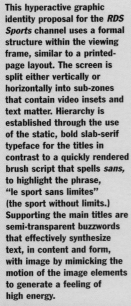

1

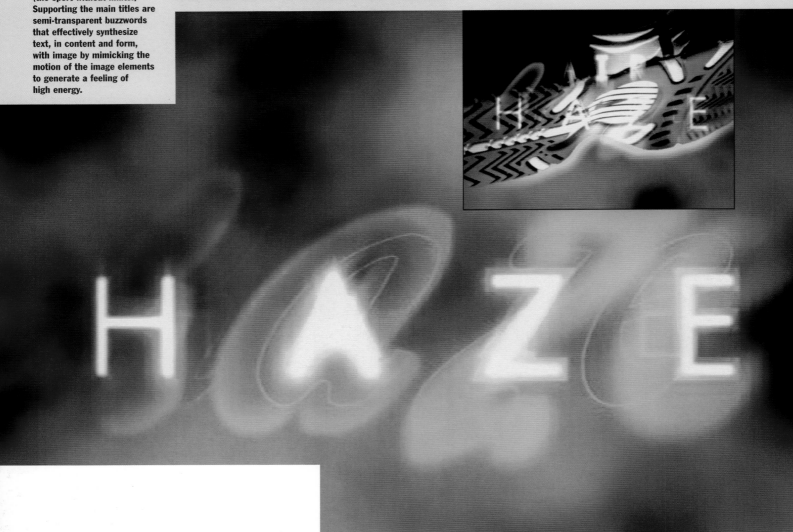

Contrast and Synthesis

Rodney Sheldon Fehsenfeld founded the Seattle, Washington-based Futile—a small creative studio which targets digital media creations for clients with interactive, audio, and visual needs—in 1995.

The brief for this project called for a psychedelic treatment that incorporated footage of Jimi Hendrix and Monica Seles for a video to be played at the roll-out party for the new Nike *Air Haze* shoe. This sequence clip represents some of the original art direction and design concepts that remain in the final version.

1. TITLE *RDS Sports Graphic Identity proposal*
FORMAT Video · ORIGIN United States
CLIENT RDS Sports, Canada · DATE 1997
DESIGNER Rodney Sheldon Fehsenfeld, Futile
COMPANY Digital Kitchen
2. TITLE *Nike Air Haze logo treatment*
FORMAT Video · ORIGIN United States
CLIENT Nike · DATE 1996 · DESIGN/ART
DIRECTION Rodney Sheldon Fehsenfeld
COMPANY Futile

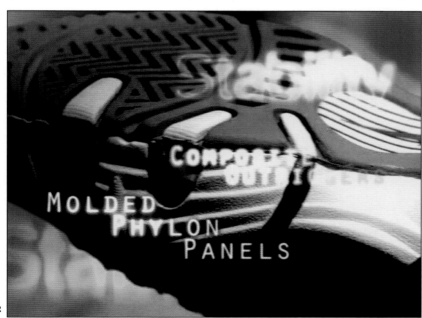

The viewing frame is filled with swirling hazy hues of red, yellow, orange, and blue which create a sublime atmosphere. In addition to the name, *Air Haze*, descriptive words are positioned over the shoe and set in a light, sans serif typeface. The text elements drift slowly around the frame-space, flash bright white and then literally vaporize as the edges of the letters soften and blur to capture the lightness and transience of the shoe in action.

2

Fast, furious, and frenetic type treatments combine with quick-cut editing and dramatic imagery to create a dynamic, high-energy, in-store promotional video for *K2*. The project was targeted at the snowboard market and intended to position skiing as a "cool" alternative to the youth-oriented sport of snowboarding.

Collisions and Agitation

TITLE *K2 In-Store Promotion* · FORMAT Video · ORIGIN United States
CLIENT K2 · DATE 1996 · DESIGN/ART DIRECTION Rodney Sheldon
Fehsenfeld, Futile · COMPANIES Cole & Weber; Digital Kitchen

A multi-layered collage of color-filled imagery which includes extreme skiing, news footage, expressways, and technical illustrations of the product and *K2* logo within a geometrically cropped viewing frame provide the backdrop for typographic treatments of descriptive phrases to tap the fast-paced nature of the audience.

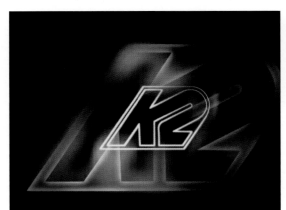

The type creates a focal point in each scene by literally dancing with the image activity in gestural manners that include vertical streaking, transparency, and collision of letterforms.

Texture

While at The DI Group, Joel Markus experimented with a wide range of technologies and techniques that led to breakthroughs in time-based typography. Joel Markus continues to pave new typographic paths with his own Massachusetts-based company, Markus: Design + Direction.

In this piece for Discovery Channel International, entitled *Lights*, a collage sequence of light rays that represent different areas of the world are combined with film footage of these regions. This fades into a bright orange cone of light that converges in the center of the viewing frame and establishes a focal point. This light activity is revealed as the foreglow of the outlined treatment of *Discovery* which moves in from the front of the viewing frame. The light rays were shot single frame on a motion-control camera and enhanced with computer technology.

1

1. TITLE *Lights* · FORMAT Film, Video · ORIGIN United States · CLIENT Discovery Channel International (Laura Frankel) · DATE 1997 · DESIGN DIRECTOR Joel Markus · DESIGNER Joel Markus · DIGITAL ANIMATOR Kirk Garfield · FILM ANIMATOR The Frame Shop, Ed Joyce · EDITOR Eli Constantine · SOUND Tom and Andy · COMPANY The DI Group

2. TITLE *ESPN International* · FORMAT Video · ORIGIN United States · CLIENT ESPN International (Andy Bronstein and Jody Markley) · DATE 1997 · DESIGN DIRECTOR Joel Markus · DESIGNER Joel Markus · ANIMATOR Kirk Garfield · EDITOR Eli Constantine · COMPANY The DI Group

3. TITLE *TBS James Bond Movie Series* · FORMAT Film, Video · ORIGIN United States · CLIENT TBS (Pat Smith) · DATE 1994 · DESIGN DIRECTOR Joel Markus · DESIGNER Joel Markus · DIRECTOR Jim Gordon · EDITOR Eli Constantine · COMPANY The DI Group

The energy in this 3-second sports promotions animation for ESPN International is meant to inspire cheerfulness. The letters E S P N swell and shrink in sequence and fuse into a pattern of interlaced blue and red line activity.

The opening imagery for this TBS—the American cable channel—series on James Bond films, inspired by Maurice Binder's acclaimed title sequences for these films, was composed through the camera lens which framed women dancing in silhouette with projected typographic treatments bending to the contours of their unclothed bodies. This imagery was layered with textures such as water or sand to further establish context and mood.

2

3

In this sequence for the Discovery Channel's *Special of the Week,* a collage of various elements help construct each letter in the word discovery. The two- and three-dimensional elements were technically composited using stop-motion animation. This was combined with film shoots of actors interacting with visual elements and computer-generated animations of letterforms moving in space.

1

Swirling, abstracted animal textures provide the backdrops in this opening sequence for *Wild Things*, a series about the animal kingdom. One by one, semi-translucent letters appear in the center of the viewing frame and spell wild.

These monumental forms are literally brought to life with live animal footage displayed within their outlined forms. Rectangular subzones also contain animal footage and provide compositional punctuation for the viewer.

Everyday objects come to life and make up human-like faces that represent the different genres the Learning Channel has to offer. These objects become typographic symbols in their modularity and interchangeability and create meaningful, compositional wholes that communicate programming areas that range from medical topics to shows about how things work.

A traditional table-top stop-motion system captured this sequence which was then transferred to video.

Assemblage and Montage

2

3

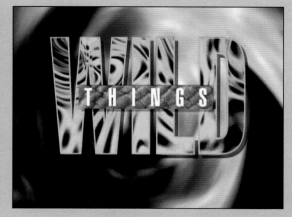

1. TITLE *Special of the Week* · FORMAT Film, Video · ORIGIN United States · CLIENT Discovery Channel (Dan Stanton) DATE 1994 · DESIGN DIRECTOR Joel Markus · DESIGNER Joel Markus · DIGITAL ANIMATOR Kirk Garfield · MODEL ANIMATOR Gabriel Polonsky · STOP-MOTION CAMERA The Frame Shop, Ed Joyce · DIRECTOR Jim Gordon · EDITOR Eli Constantine SOUND Sound Techniques · COMPANY The DI Group
2. TITLE *Wild Things* · FORMAT Video · ORIGIN United States · CLIENT Discovery Channel (Dan Stanton and Mary Claire Baguet) DATE 1994 · DESIGN DIRECTOR Joel Markus · DESIGNERS Joel Markus, Ron Pearl · EDITOR Eli Constantine · FILM FOOTAGE The Discovery Channel · COMPANY The DI Group
3. TITLE *Learning Channel Daytime Identity* · FORMAT Video · ORIGIN United States · CLIENT The Learning Channel (Mike Coslow) · DATE 1994 · DESIGN DIRECTOR Joel Markus · DESIGNER Joel Markus · EDITOR Eli Constantine · ANIMATOR Mark Frizzell · COMPANY The DI Group

4 [Form]

Digital technology has freed the letterform from the static and fixed object-symbol we associate with the modern Western alphabet. With the aid of desk-top computers and software, letters are rendered as outlined shapes with malleable properties waiting to be brought to life. This chapter considers choreographic, musical, operatic, painterly, sculptural, architectural, plastic (metamorphic and mutational), liquid, and even intelligent roles that letterforms may assume in time-based and three-dimensional situations.

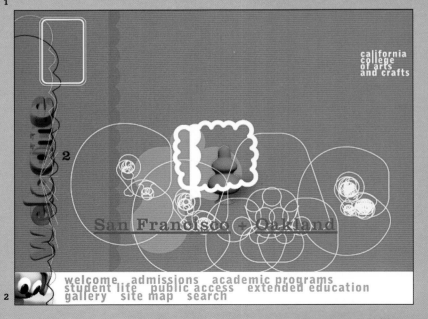

(1) The Gravitech screen saver takes advantage of a computer user's downtime by offering visually stimulating poetry on the resting video monitor. Controlled by a random text and image generator, elements fade in and out of a blackened background to create a seemingly endless layering and depth at a guaranteed rate of one poetic work every ten minutes (or so).

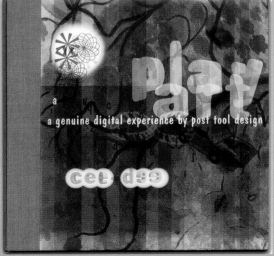

Plasticity

Post Tool Design, a California-based partnership, was formed in 1993 by David Karam and Gigi Biederman. They specialize "in the strange and beautiful" with their multimedia products inhabited by surreal characters, organic objects, three-dimensional letterforms, and other-worldly color palettes.

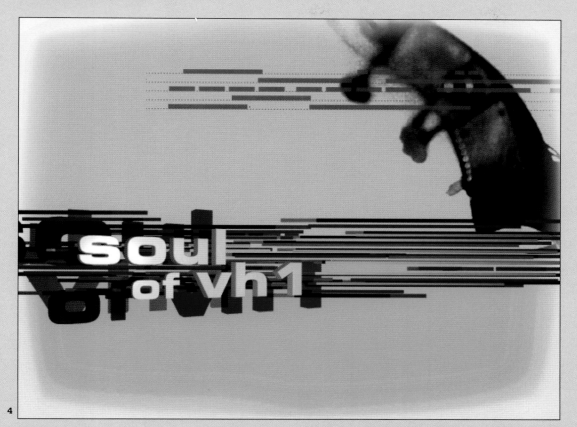

4

1. TITLE *Gravitech Screen Saver* · FORMAT Digital Media · ORIGIN United States · CLIENT Post Tool · DATE 1996 PROGRAMMING & FORAGING David Karam · MUSIC Tom Blanc · COMPANY Post Tool
2. TITLE *CCAC Website* · FORMAT Digital Media · ORIGIN United States · CLIENT Post Tool · DATE 1998 · DESIGNERS David Karam, Gigi Biederman · ILLUSTRATION & PROGRAMMING David Karam · UNIVERSITY California College of Arts and Crafts
3. TITLE *Play Art (Ultra Type Sample)* · FORMAT Book · ORIGIN United States · CLIENT Post Tool · DATE 1997 · DESIGN, COLLAGE & DOODLING Gigi Biederman · ILLUSTRATION, DOODLE PROGRAM David Karam · COMPANY Post Tool
4. TITLE *VH1 Identity* · FORMAT Video · ORIGIN United States · CLIENT Post Tool · DATE 1996 · DESIGNERS David Karam, Joan Raspo · COMPANY Post Tool

(2, 3) The website for the California College of Arts and Crafts and the printed cover for *Play Art* display the signature typographic treatments of Post Tool. Three-dimensional letterforms are frozen in motion against a backdrop of collaged gestural line activities to create a sense of endless space.

(4) These identity spots for the music channel VH-1 continue the exploration of dimension, motion, and space. In all examples, letterforms are monumental objects that are not simply pasted flat and frontally on the surface, but actually occupy real space in these surreal environments.

Visual Overload and Distortion

The unlikely substances of smoke and ink formulate letterforms that spell answers to provocative questions on the *Post TV* CD-ROM.

What is air?

How many hearts does an octopus have?

Do you know someone who is sweet as sugar or someone who is mean as can be?

Let me whisper in your ear...

What am I?

Intuitive creativity is the theme behind this interactive press kit that promotes *King for a Day,* an album by the progressive rock band Faith No More. The user can explore five different environments, one of which, presented on these pages, turns the computer screen into a digital canvas.

A selection of four different marking devices allow the user to create visually layered, textured, energetic compositions inspired by the electrically and vocally dense, and intense, sounds of this musical group.

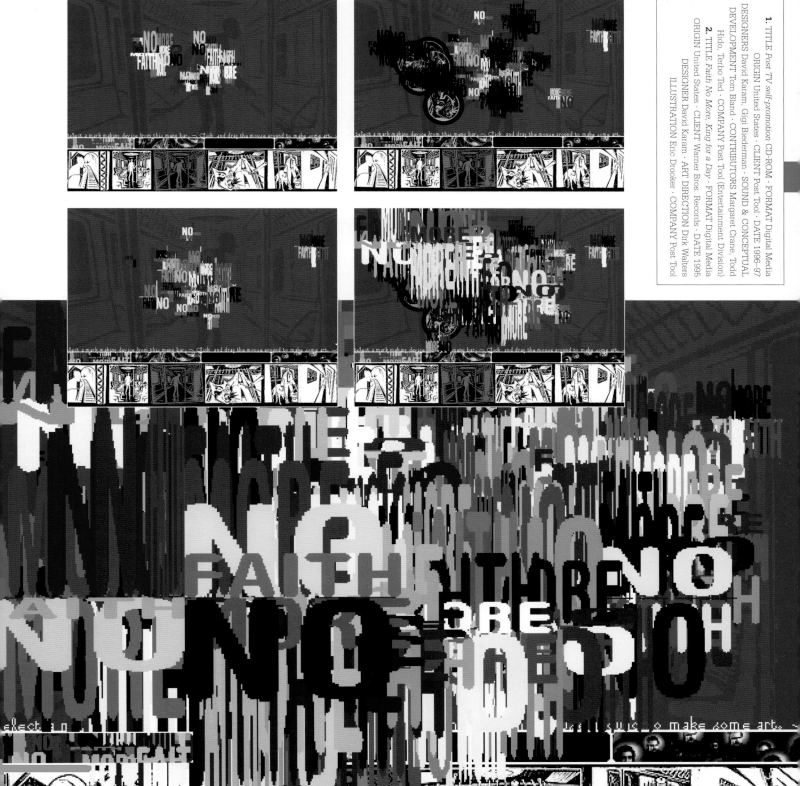

1. TITLE *Post TV self-promotion* CD-ROM · FORMAT Digital Media
· ORIGIN United States · CLIENT Post Tool · DATE 1996–97 ·
DESIGNERS David Karam, Gigi Biederman · SOUND & CONCEPTUAL
DEVELOPMENT Tom Bland · CONTRIBUTORS Margaret Crane, Todd
Hido, Terbo Ted · COMPANY Post Tool (Entertainment Division)
2. TITLE *Faith No More, King for a Day* · FORMAT Digital Media
· ORIGIN United States · CLIENT Warner Bros. Records · DATE 1995
· DESIGNER David Karam · ART DIRECTION Dirk Walters ·
ILLUSTRATION Eric Drooker · COMPANY Post Tool

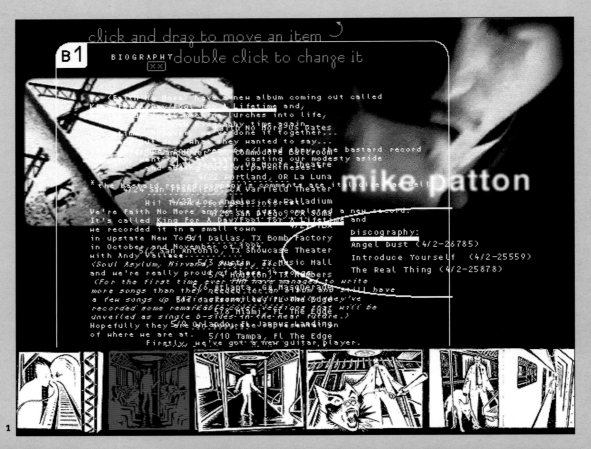

The *Faith No More* interactive press kit captures the pace and energy of pop culture, offering visual experimentation with the transfer of collage sensibilities from a physical to a digital medium.

The environment on this page displays text-based data on the band such as a discography, song lyrics, reviews, and interviews over abstract imagery. The user may click on any block of text and drag it to a new location, over another layer of text.

1

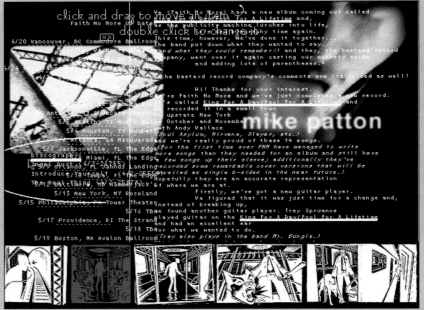

Interacting with Illustration

Gravity is an interactive promotional for a pop group. Amidst a backdrop of mesmerizing, synthesized sounds, the user is sent on a journey through a collection of texts and must determine if the information presented is fact or fiction.

The interface is constructed around the word gravity, the letters of which pulsate, mutate, disappear, and reappear over fragmented images. The information revealed by clicking on these letters allows the free motion and collaging of text elements in the same manner that data moves unrestrained through transmission vehicles.

2

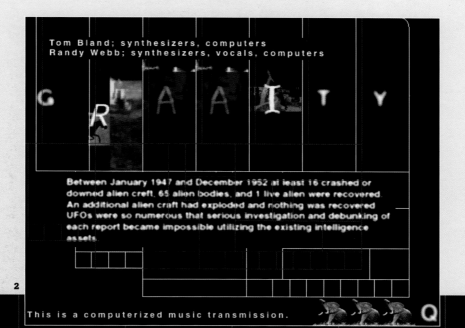

1. TITLE *Faith No More, King for a Day* · FORMAT Digital Media · ORIGIN United States · CLIENT Warner Bros. Records · DATE 1995 · DESIGNER David Karam · ART DIRECTION Dirk Walters · ILLUSTRATION Eric Drooker · COMPANY Post Tool
2. TITLE *Gravity* · FORMAT Digital Media · ORIGIN United States · CLIENTS Gravity, Post Tool · DATE 1994 · DESIGNER David Karam · DOODLE ART Gigi Biederman · MUSIC Gravity; Tom Bland, Randy Webb · COMPANY Post Tool

Within the image:
Tom Bland; synthesizers, computers
Randy Webb; synthesizers, vocals, computers

Between January 1947 and December 1952 at least 16 crashed or downed alien craft, 65 alien bodies, and 1 live alien were recovered. An additional alien craft had exploded and nothing was recovered. UFOs were so numerous that serious investigation and debunking of each report became impossible utilizing the existing intelligence assets.

This is a computerized music transmission.

Drug Use Among U.S. Teens
WASHINGTON (Reuter) - Drug use among American teenagers seem increasingly about the physical and emotional hazards of drugs, federal officials said Monday.
"The potential for trouble is enormous," Education Secretary Richard Riley said. "we need to turn around this new 'no sweat' attitude about drugs that seems to be gaining hold among some of our young people."
Anti-drug messages have been heeded in the past but...

we have to repeat our message with the same level of intensity for each new generation.

LSD use was approaching 1970s levels, the survey found. Use of powdered and crack cocaine also rose among eighth and 10th graders in 1994. But after a period of decline alcohol use was stable among teens.

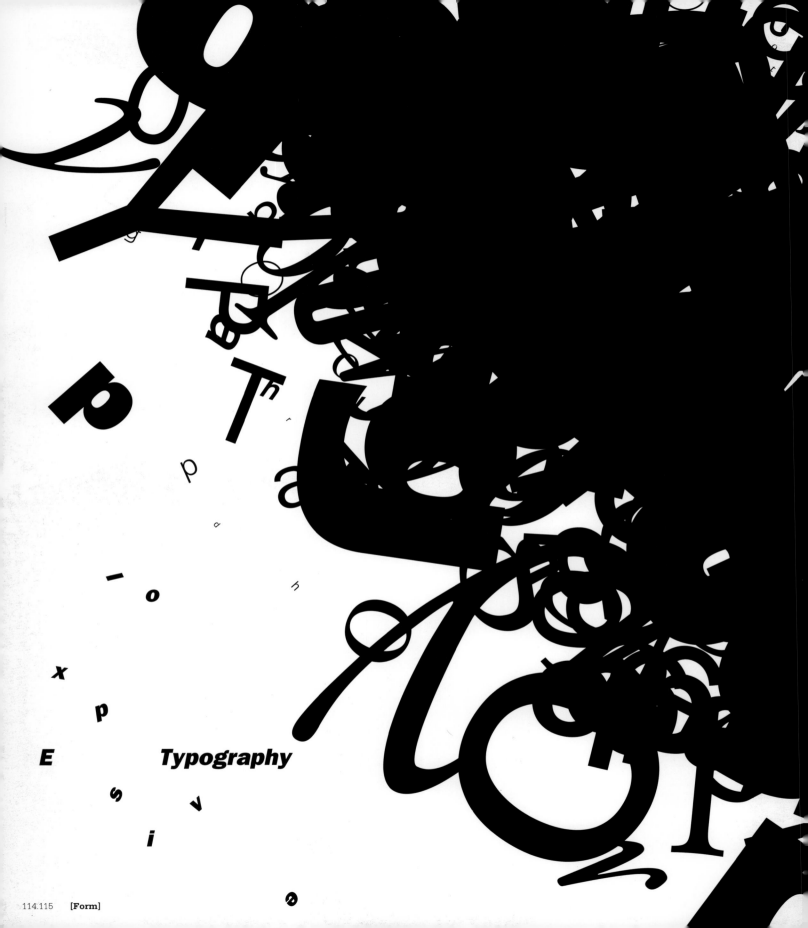

Typography

Typefaces Come Alive

[T-26] Type Foundry is a division of Segura, Inc., based in Chicago. These short quick-time movies are made to promote the innovative and experimental typefaces the foundry creates.

OMAHA
by [T-26]

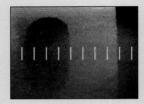

BOX
by Margo Chase

PROTON
by Patrick Glasson

POSTMORTEM
by Susána de Tembleque

SPIRIT
by Planet Design Company

VOILA
by Hat Nguyen Design

AIDING ™
A collection of 59 Dingbats by assorted designers.

AMPLIFIER
by Frank Heine

AVIATOR
by [T-26]

GODLIKE
by Peter Bruhn

DROPLET
by Hat Nguyen Design

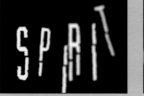

FLUX
by [T-26]

DIVINE
by 52 mm and Ben Conrad

TITLE *Font Movies* · FORMAT Digital Media · ORIGIN United States · DATE 1998 · COMPANY [T-26] Type Foundry, a division of Segura, Inc. · ©1998 [T-26]

1

1. PROJECT *Class Assignment* · FORMAT 16 mm
Film · ORIGIN New Zealand · DATE 1996
INSTRUCTOR Jeff Bellantoni · DESIGNER Evan
White · UNIVERSITY Wanganui Polytechnic School
of Art and Design
2. PROJECT *The Elements of Print Typography*
FORMAT Digital Media · ORIGIN United States
DATE 1997 · INSTRUCTOR Michael Worthington
DESIGNERS Andrea Tinnes, Chris Selby
UNIVERSITY California Institute of the Arts

the PRINCIPLES
of TYPOGRAPHIC structures
HIERARCHY

Once the space within a book was carefully measured and well defined everything had its assigned place

the PRINCIPLES
of TYPOGRAPHIC structures
HIERARCHY
The process of linear reading itself predestined the structure of the text

Once the space within a book was carefully
measured and well defined
into *everything had its assigned place*

measured and well defined **and this is now**
Once the space within a book was carefully
everything had its assigned place
this was then

the PRINCIPLES
...
four-sided frame of the single page

As we have entered a domain
we may find room for new ways of perceiving
where the established parameters of
a body of information
print typography are constantly
shifting

In the digital realm
the reader turns into
an active user, provided
with the activities of

In the digital realm
the reader turns into
an active user, provided
with the activities of
reading viewing
choosing interacting

the quality of new media

typography
denoting hierarchy is a key tool
of orientation and mapping
guiding the user through the
aemz
of four-dimensional spaces
helping him to find his path
in a simultaneously **SEDUCTIVE**
and
overwhelming environment
...unconventional

environment *typography*

are replaced by the means of
TIME.

of interaction the user is becoming

control
HIERARCHY

director

Textural Animation

This project is part of an interactive course, in which students are introduced to designing with multimedia and web authoring software. Each student is given an element of print typography and asked to look briefly at its origins and current usage, and then visually hypothesize on its possible future in the digital realm. The final result is intended to be an animated piece for the CalArts website.

On the opposite page, what began as a student's animation project, working directly onto 16mm film, became a beautiful typographic dance of letterforms and textures. The process of scratching and drawing directly onto film helps students understand how a sequence is structured through the projection of individual frames and how we see motion through the phenomenon of persistence of vision.

2

Programming
a New Language

LettError is a two-person—Erik van Blokland and Just van Rossum—virtual design studio that endeavors to make typefaces that do more than sit on a baseline, look pretty, and deliver a message. They use unique programming of their fonts—the digital files that contain their end-user typeface designs.

1. TITLE *LettError Name Thing* · FORMAT Digital Media · ORIGIN The Netherlands · DESIGNERS Erik van Blokland, Just van Rossum · COMPANY LettError · CREDITS LettError Design for Time ™ cdrom, ©1998 LettError, all rights reserved

2. TITLE *PockeRocket Animation* · FORMAT Digital Media · ORIGIN The Netherlands · DESIGNERS Erik van Blokland, Just van Rossum · COMPANY LettError · CREDITS LettError Design for Time ™ cdrom, ©1998 LettError, all rights reserved

3. TITLE *FontShop Televisions* · FORMAT Digital Media · ORIGIN The Netherlands · DESIGNERS Erik van Blokland, Just van Rossum · COMPANY LettError · CREDITS LettError Design for Time ™ cdrom, ©1998 LettError, all rights reserved

4. TITLE *BitPull Type Movie* · FORMAT Digital Media · ORIGIN The Netherlands · DESIGNERS Erik van Blokland, Just van Rossum · COMPANY LettError · CREDITS LettError Design for Time ™ cdrom, ©1998 LettError, all rights reserved

BitPull is not a actually a font, but a system that consists of one small computer application and a collection of outline fonts that allow users to tear typographic characters apart pixel-by-pixel, fold them along curves, stretch, scale, and distort them in ways never thought possible.

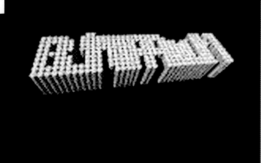

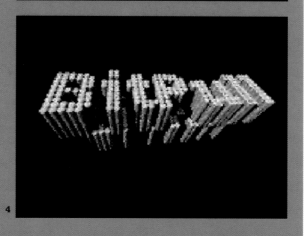

Character manipulation with *BitPull* is accomplished with the help of the *BitPuller*, which converts selected text into LettError-designed bitmaps. Each bitmap is made of a pattern of pixels in the form of a typographic character. Each vertical line of the pixels in these bitmaps translates into one character of a *BitPull* outline font. This means one character converted into BitPullese may have multiple parts—or linked vertebrae—that can twist and bend to the user's typographic desires.

3

4

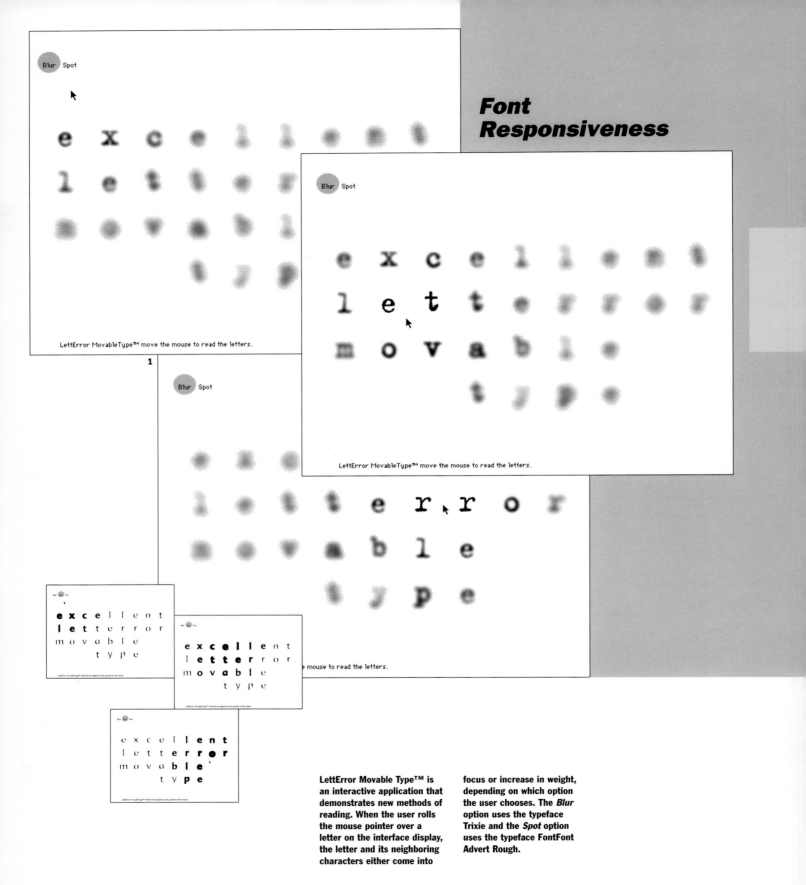

Blur Spot

Blur Spot

Blur Spot

LettError MovableType™ move the mouse to read the letters.

LettError MovableType™ move the mouse to read the letters.

1

Font Responsiveness

LettError Movable Type™ is an interactive application that demonstrates new methods of reading. When the user rolls the mouse pointer over a letter on the interface display, the letter and its neighboring characters either come into focus or increase in weight, depending on which option the user chooses. The *Blur* option uses the typeface Trixie and the *Spot* option uses the typeface FontFont Advert Rough.

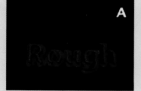

FF Advert
Rough

2

1. TITLE *LettError Movable Type*™ · FORMAT Digital Media · ORIGIN
The Netherlands · DESIGNERS Erik van Blokland, Just van Rossum
COMPANY LettError · CREDITS LettError Design for Time ™ cdrom,
©1998 LettError, all rights reserved

2. TITLE *FF Advert Rough Type Movie* · FORMAT Digital Media · ORIGIN
The Netherlands · DESIGNERS Erik van Blokland, Just van Rossum
COMPANY LettError · TYPE MOVIE Just van Rossum ©1993 LiTTRRtv
JvR · CREDITS LettError Design for Time ™ cdrom. ©1998 LettError, all
rights reserved · TYPEFACE FontShop International

FontFont Advert Rough
is a typeface in which each
letter is made up of several
interlocking shapes. As a
result, all the letters have
the same character width.
The stills shown here are
from a type sequence created
to promote the typeface and
its capabilities.

A typographic character with a rough edge to it casts the impression that some imperfect production technique was used in its rendering: cut from wood, photocopied several times, printed at a low resolution, stamped with an old, ink-swelled typewriter. When typefaces are deliberately created with this quality and are vectorized into a font file, the computer replicates every single detail of dirt and grit each time the same letter is typed. This is a paradox. A certain imperfection or varying unevenness is noticeable to the eye because it is by nature unique, random, accidental, and cannot be duplicated. Users have grown accustomed to clean, non-varying type because technological advances allow the efficiencies of using one form to reproduce a character many times at a high resolution. This is how printing evolved: Always striving for efficiency, consistency and clarity of reproduction. In the reading process, this sameness is not necessary. We are capable of reading handwritten text, smudgy

1

Randomness and Irony

aaaaaaaaaa

WHAT YOU See WHAt yOU Get IS A FONtFOR FUSE 11 tHAt SHOWS SOMetHINg dIFFeRENt

WHAT YOU See WHAt yOU Get IS A FONt

Typoman Adventures is a series of animations that present concerns about contemporary issues in typography. Typoman saves the width of a lowercase "a" being squeezed by the bullying uppercases "A" and "B" in *Capital City*. In *The Reason Y*, Typoman uses a raygun to annihilate Alien Font Pirates who are cloning letterforms. "Never thought RayGun would save typography," says Typoman.

In *Typoman Saves a Tree*, the hero discovers that newspapers are made of live trees and promotes reading the news online.

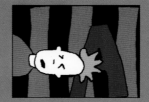

3

letters on a newspaper, and even type superimposed on flickering television images. The sameness of type seems an arbitrary condition that we can do away with in certain cases. PostScript technology allows the designer to build a font program that modifies, changes or switches letterforms. FontFont Beowolf is the first font (1989) LettError built with a randomization routine. All points on the contour of a fairly normative typeface are given a space in which they can freely move. So instead of each letter having a single, fixed form, the shape is flexible and wobbles according to its frequency of use. If a character is repeated in a text several times, this character will print differently in each occurance.

Z Z Z Z Z Z

1. TITLE *FF Beowolf* · FORMAT Typeface · ORIGIN The Netherlands · DATE 1989 · DESIGNERS Erik van Blokland, Just van Rossum · COMPANY LettError · CREDITS FontShop International
2. TITLE *What You See* · FORMAT Typeface · ORIGIN The Netherlands · DESIGNERS Erik van Blokland, Just van Rossum · COMPANY LettError · CREDITS Fuse 11
3. TITLE *Typoman Adventures Animation: "Capital City"* · FORMAT Digital Media · ORIGIN The Netherlands · DESIGN & ANIMATION Erik van Blokland · SOUNDTRACK & MUSIC Just van Rossum · COMPANY LettError · MOVIE ©1996 LTTRRR · CREDITS LettError Design for Time ™ cdrom, ©1998 LettError, all rights reserved

ON SCREEN tHAN It PRINtS FOR FUSE 11 tHAT SHOWS SOmetHING dIFFERENt ON

SCREEN tHAN It PRINtS

2

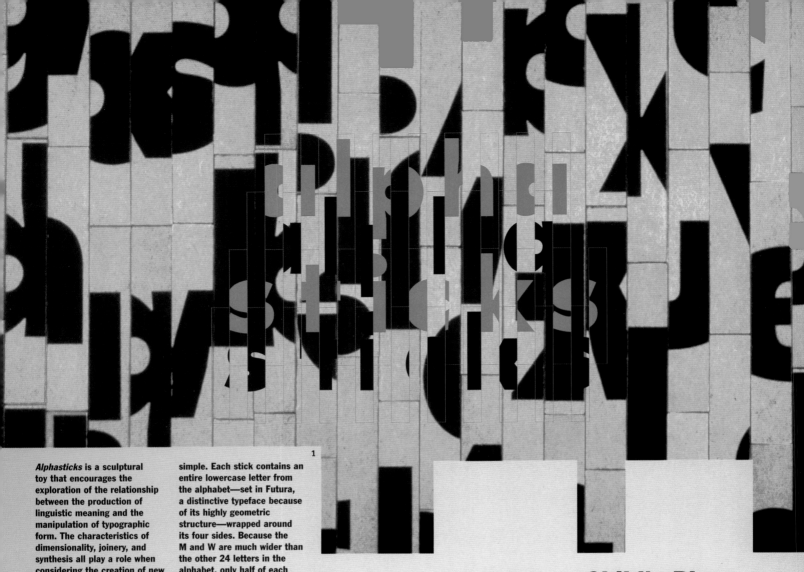

1

Alphasticks is a sculptural toy that encourages the exploration of the relationship between the production of linguistic meaning and the manipulation of typographic form. The characteristics of dimensionality, joinery, and synthesis all play a role when considering the creation of new typographic forms for adaptation to digital environments. The construction of *Alphasticks* is simple. Each stick contains an entire lowercase letter from the alphabet—set in Futura, a distinctive typeface because of its highly geometric structure—wrapped around its four sides. Because the M and W are much wider than the other 24 letters in the alphabet, only half of each of these letters is contained on a single stick.

Child's Play

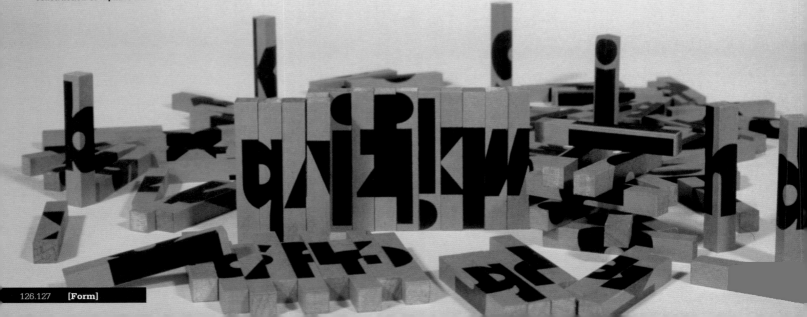

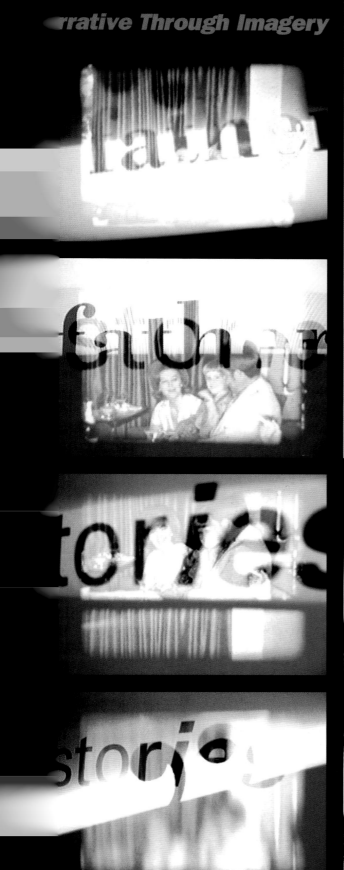

1. TITLE *Alphasticks*™ · FORMAT Mixed: Basswood, Craft Paper, Primer, Toner · ORIGIN United States · DATE 1997 · CONCEPT AND DESIGN Matt Woolman · PACKAGING San Van · COMPANY -ization ©1997
2. TITLE *Father Stories* · FORMAT Super 8 Film, Video · ORIGIN United States · DATE 1995 · DESIGNER Jeff Bellantoni · COMPANY -ization
3. TITLE *Sweet Sound Music Video* · FORMAT 16 mm Film, Video ORIGIN New Zealand · DATE 1996 · DESIGNER Jeff Bellantoni COMPOSER/MUSICIAN Ben Woolman · COMPANY -ization

3

The music video for *Sweet Sound* uses a 16mm scratch film combined with video, set to a composition by the guitarist Benjamin Woolman. The type sequence shown here represents the opening sequence and end credits.

Sound and Vision

Father Stories is a series of short experimental quick-time movies incorporating type and old 8mm film footage of the designer's family. The objective is to tell stories about the father using mostly type interacting with the imagery on the film. The designer deliberately omitted audio in a effort to set the limitation of telling these stories using only type and image.

The type seen in this sequence was captured with a video camera directly from a computer monitor display. The designer adjusted the shutter speed on the camera to exploit the scan lines of the monitor. Dynamic and unintentional shapes result as the scan lines merge with the letterforms.

2

Experiments in Formalism

Designing with the letterform is a basic means of training for education in visual forms. By creating an individual sign and joining letters together into a group or a word, the student awakens and develops a feeling for forms in general. He gains a knowledge of the proportional, rhythmical and stylistic characteristics of letterforms, which enables him to visualize a form concept and to carry the work through to a unified whole... by altering the sign, the student investigates the mobility and variability of letterforms, explores their possibilities of expression and learns to determine the limits of freedom in their creation. In this way he also develops his own creativity.

—Andre Gürtler, from a special issue of *Typographische Monatsblätter*, originally in *Letterforms and Film*, a Basle School of Design publication.

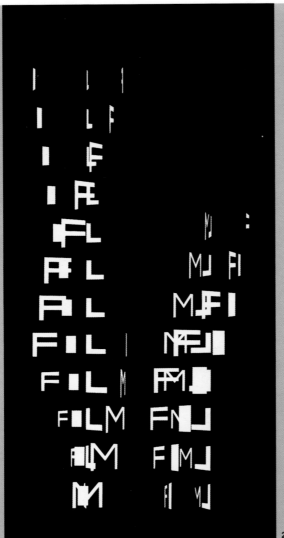

1

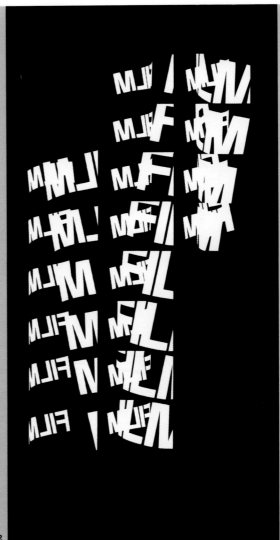

2

The Department of Visual Communication at the Basle School of Design in Switzerland has been committed to the study and teaching of the letterform in film and video for over 25 years. The sequences on these pages represent significant projects done by students and instructors in the program.

The letterform evolved through its use in a two-dimensional, static format. The adaptation of letterforms to a time-based situation requires an additional set of formal and behavioral considerations. Sequences 1 and 2 are basic exercises that demonstrate the filmic function and optical effects that occur during the projection of letterforms.

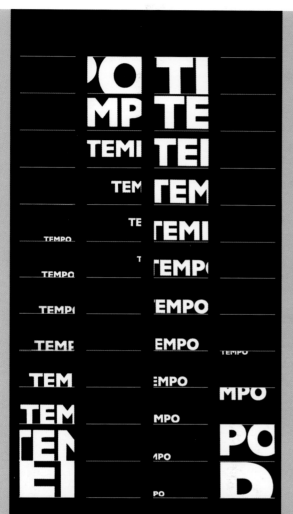

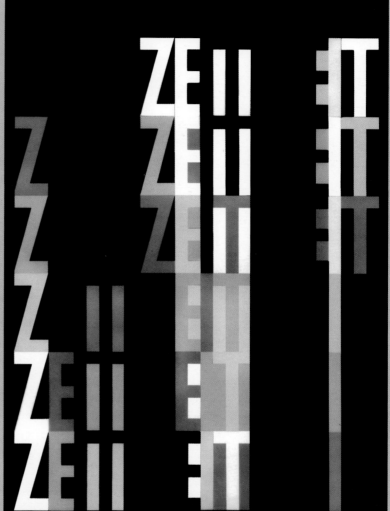

PROJECTS *Letterforms and Film, 25 years of Film Studies at the Basle School of Design* · FORMAT Film · ORIGIN Switzerland · INSTRUCTORS Peter Von Arx, Fabian Kempter, Richard Manz, Gregory Vines · ADDITIONAL INSTRUCTORS Max Mathys, Werner Bürgin, Peter Tschan, Peter Olpe · UNIVERSITY Basle School of Design

3

4

Speed and time play a major role in effectively communicating a message in a time-based situation. Sequences 3 and 4 represent exercises that explore these two basic elements of film structure.

The word tempo is used as an image as much as a word through the combination of scale with speed and time.

The letters of the word zeit (time) go through a transition, with the subtle gray values dissolving in this sequence. The changes occur at a tempo that corresponds to the naturally slow pace of time.

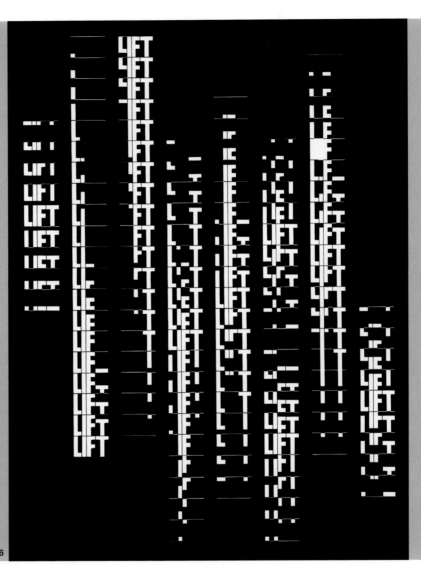

5

6

The adaptation of type to film allows new interpretations of letterforms as carriers of meaning. Sequences 5–8 represent exercises in film that bring typographic form closer to meaning.

(5) In this sequence, the viewing frame becomes a cropping window through which the word maske moves and shifts in scale. A small masked rectangular shape creates a sub-zone in the center of the frame to crop the letters further into abstract shapes that flirt with the viewer's sense of figure/ground and solid/void.

(6) The letters in the word lift ascend and descend in a group and independently. The viewing frame crops this activity to offer a sense of space and depth.

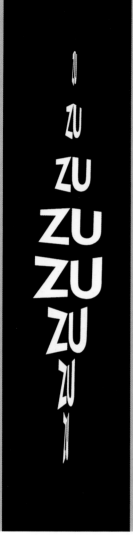

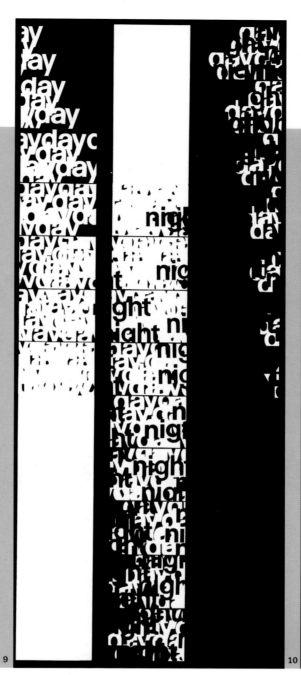

PROJECTS *Letterforms and Film, 25 years of Film Studies at the Basle School of Design* · FORMAT Film · ORIGIN Switzerland · INSTRUCTORS Peter Von Arx, Fabian Kempter, Richard Manz, Gregory Vines · ADDITIONAL INSTRUCTORS Max Mathys, Werner Bürgin, Peter Tschan, Peter Olpe · UNIVERSITY Basle School of Design

7 8 9 10

(7) The word zu (to) spins on an invisible axis in this sequence in which a simple word is interpreted in direct correlation with its meaning.

Sequences 9 and 10 stem from exercises which go beyond more or less abstract interpretations of the words and attempt to illustrate the meaning of the words in a more humorous or romantic sense/manner.

The word day multiplies itself until the black viewing frame is completely overtaken by the white of the letters. The word night then appears, multiplying itself to reclaim the frame.

The contrast of the counterforms to the letters in this sequence create a horizon as the word day rises and the word night falls.

(8) The word lux (light) is revealed with self-referential meaning as it passes through a darkened viewing frame.

11 12 13 14

In this project students have to choose two letters which, when paired, are generally understood as a sign, e.g., TV, CD, IQ, AM, PM, etc. The students then combine their letters with a simple graphic element in a time-based sequence.

In the above sequences, the letter signs IQ, ai, DM, and xy move through a viewing frame that contains an invisible circular sub-zone. When the letters pass through this zone an action takes place that is different from the action outside the zone: cropping, pace, magnification, focus, fracture, rotation. The result is that the circle is only perceptible because of this difference.

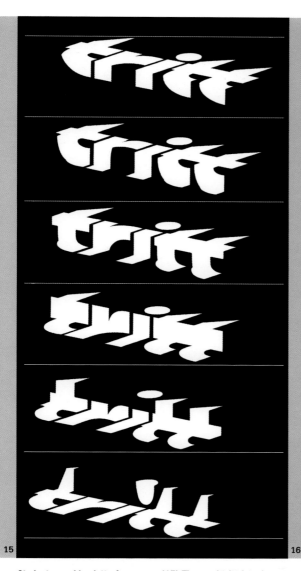

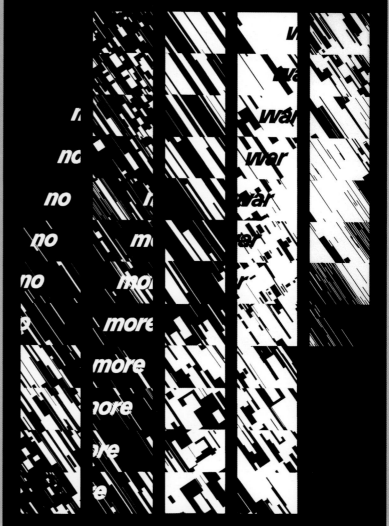

PROJECTS *Letterforms and Film, 25 years of Film Studies at the Basle School of Design* · FORMAT Film · ORIGIN Switzerland · INSTRUCTORS Peter Von Arx, Fabian Kempter, Richard Manz, Gregory Vines · ADDITIONAL INSTRUCTORS Max Mathys, Werner Bürgin, Peter Tschan, Peter Olpe · UNIVERSITY Basle School of Design

15

16

Students combine letterforms with figurative elements in these more advanced projects.

(15) The word tritt (step) bends at right angles to assume the footers and risers of a stairway.

Professor Peter Von Arx designed this film sequence for an anti-war campaign during the Vietnam War.

The words "no more war", set in a bold, unadorned, sans serif typeface, move horizontally from right to left in the viewing frame in opposition to the random, dense pattern of variable-weight line elements raining down at an angle from the upper left to the lower right. This dynamic contrast in movement set in stark black and white creates a visually stimulating tension that attracts the eye, but communicates a flurry of violence.

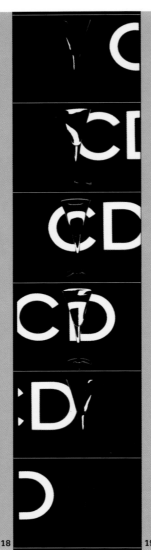

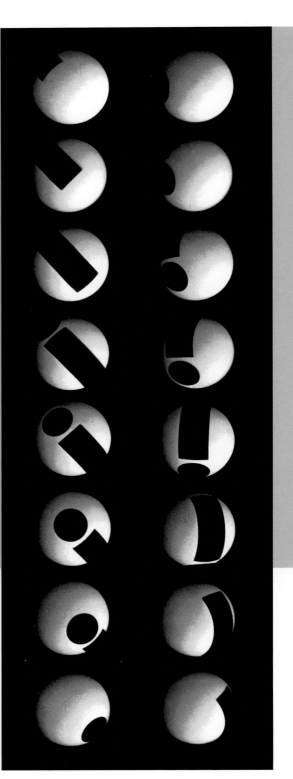

17

18

19

The letters E H E are used
in an interpretation of the
theme of marriage crisis.
The hardline, geometric
contour of the E dissolves
into particles that reform into
the H. The rigid structure of
the H then breaks down into
an amorphous form that re-
forms back into the E.

The champagne glass
becomes visible through
the reflection of the C and
D as they move horizontally
behind the glass. The letters
C and D establish contextual
meaning through their
association with the glass.

The logo for inlingua, a
worldwide language school,
comes to three-dimensional
and kinetic life in an animated
sequence created for the
institute's annual congress.

Shadows revealed through cut paper allow the word ombra to become visible and legible.

21

20

This excerpt from a student's diploma project sequence is based on the theme ecran—French for cinematic projection screen. The meaning behind this typographic treatment comes to life as the letters mimic the flow of an opening curtain.

The letter T is the subject of this formal study which uses black droplets of ink and the white background to render the character visible and invisible.

22

PROJECTS *Letterforms and Film, 25 years of Film Studies at the Basle School of Design* · FORMAT Film · ORIGIN Switzerland · INSTRUCTORS Peter Von Arx, Fabian Kempter, Richard Manz, Gregory Vines · ADDITIONAL INSTRUCTORS Max Mathys, Werner Bürgin, Peter Tschan, Peter Olpe · UNIVERSITY Basle School of Design

Free Associations

Bob Aufuldish and Kathy Warinner formed their design office in 1991 in the San Francisco area. Their digital type foundry, fontBoy (www.fontboy.com) was established early in 1995 to release their typefaces and dingbats. The foundry's releases explore the realm of baroque modernism.

This digital portfolio presents the work of Aufuldish & Warinner. The presentation combines CD packages (real and imagined) and other print projects in a form that demonstrates how they think about interactive projects.

The interface assumes the user is curious and not intuitively deficient. Each piece in the portfolio can be accessed in any order and within each project there is a separate animated sequence. Presented on these two pages are a selection of stills.

1

Screens do not really need to be saved anymore—computer monitors are now constructed so pixel burn is no longer a problem. So how should the screen saver be recast, now that it is obsolete? Should it provide inspiration? Ask questions? Illuminate the frustration inherent in working? Make you feel inadequate?

1. TITLE A&W Portfolio · FORMAT Digital Media · ORIGIN United States · CLIENT Aufuldish & Warinner · DATE 1994–96 · DESIGNER Bob Aufuldish · SOUNDS Scott Pickering, Bob Aufuldish · PROGRAMMING Bob Aufuldish · COMPANY Aufuldish & Warinner
2. TITLE fontBoy Screen Saver · FORMAT Digital Media · ORIGIN United States · CLIENT fontBoy · DATE 1997 · DESIGNER Bob Aufuldish · WRITER Mark Bartlett · SOUNDS Bob Aufuldish · FONT DESIGNERS Bob Aufuldish · PROGRAMMING David Karam, Dave Granvold · FONT DESIGNERS Bob Aufuldish, Kathy Warinner · COMPANY Aufuldish & Warinner

a dangerous **object**

The quotes flash too quickly to read at first glance. Over time, as the same quotes appear again and again, they begin to acquire a kind of sense. After all, if the screen saver is operating, doesn't that mean you should be working? Or at least taking a nap?

The fontBoy screen saver uses nine quotes from Mark Bartlett's essay, "Beyond the Margins of the Page," which comment on the cultural significance of graphic design. Combined with a soundtrack of snoring, the quotes are randomly placed on the screen in seven different typefaces, two of which are unreadable.

Theory and Whimsy

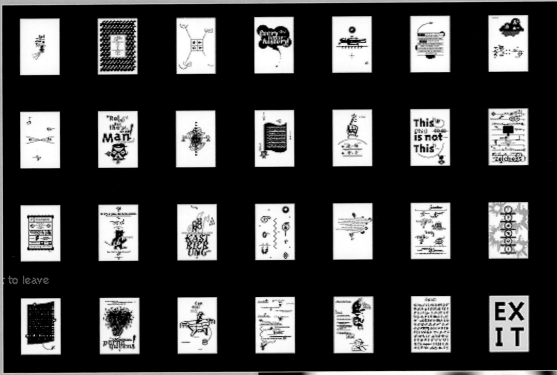

Selected Notes 2 ZeitGuys is a collaborative work that seeks to connect ZeitGuys—a collection of 126 illustrations in font format. Mark Bartlett wrote a pun-filled text based on the subtleties of French cultural theory to connect the Guys and Bob Aufuldish then designed pages based on the diagrammatical writing of Mr Bartlett.

Although the project was originally conceived for print, the screen-based version is significantly different. Each page appears out of focus, but by moving the mouse around the screen, bits and pieces of the page then appear in focus. This "pop-up" interface makes the process of navigating the page apparent—the cursor, via the mouse, becomes a metaphor for the process of distilling sense from a text made oblique (or blurry) by many layers of meaning.

1

Pop-up Navigation

This interactive press kit promotes Soul Coughing's *Ruby Vroom* CD. The ipk seeks to project the band's wacky over-the-top personality with multiple layers of animation and loud typography. Three songs are highlighted: *Screenwriter's Blues*, *Blueeyed Devil*, and *Down to This*. Each screen features roll-overs: areas where other imagery and animations are revealed when the cursor passes over them.

The press kit includes disparate kinds of information which can create confusion in organization and navigation. This problem was solved by employing a pop-up interface. When the cursor is moved around the screen, small hidden typographic animations appear. Additionally, large text blocks are stored off to the side of each major screen—they can be dragged into view if desired.

1. TITLE *Selected Notes 2 ZeitGuys* · FORMAT Digital Media · ORIGIN United States · DATE 1994 · PUBLISHER Center for Design Studies, Virginia Commonwealth University · DESIGNER Bob Aufuldish · WRITER Mark Bartlett SOUNDS Bob Aufuldish · PROGRAMMING Bob Aufuldish ICONS Bob Aufuldish, Eric Donelan · COMPANY Aufuldish & Warinner
2. TITLE *Soul Coughing Interactive Press Kit* · FORMAT Digital Media ORIGIN United States · CLIENT Warner Brothers Records · DATE 1995 CREATIVE DIRECTOR Jeri Heiden, Warner Brothers Records · ART DIRECTOR Kim Biggs, Warner Brothers Records · ART DIRECTOR/DESIGNER Bob Aufuldish · MUSIC Soul Coughing · PROGRAMMING David Karam, Bob Aufuldish · COMPANY Aufuldish & Warinner

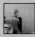

Screen Versus Print

Michael Worthington teaches in the Graphic Design Program of the Art School at the California Institute of the Arts, where he is also Director of the Macintosh Lab. With his company Worthington Design, he makes typography and design for both print and screen. His work has been published internationally.

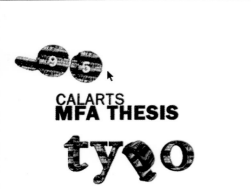

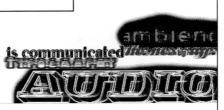

1

Worthington's Master of Fine Arts thesis at CalArts explores the possibilities of typography in digital environments. During this self-running screen presentation, a voice-over narrator begins by discussing various characteristics associated with print-based typography while typographic elements build upon one another on screen.

As the screen activity transforms from a clean layout reflective of traditional printed communication to a completely immersive, highly layered, navigable space, the narrator presents ideas and considerations one must make in applying type to completely digital environments such as websites, multimedia.

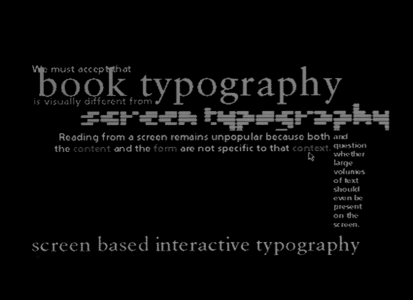

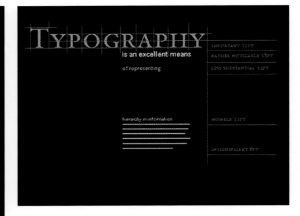

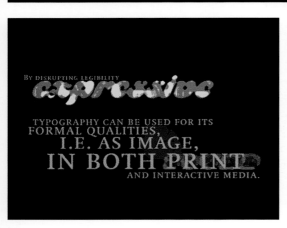

1. TITLE *Hypertype* · FORMAT Digital Media · ORIGIN United States · DATE 1995
DESIGNER Michael Worthington · UNIVERSITY California Institute of the Arts
2. TITLE *Typewriter Website* · FORMAT Digital Media · ORIGIN United States
DATE 1997 · DESIGNER Michael Worthington · COMPANY Worthington Design

Typewriter is a website
that addresses typography,
design, fiction, and criticism.
Among the many experiments
available for viewing on this
site are animations for the
type foundry Cookin' Fonts.

5 [Environment]

The influx of user-friendly digital technologies and the dramatic growth of the Internet in the 1990s opened the doors to a higher level of experimentation and carved paths to new adaptations. This chapter considers environments—physical and virtual—into which otherwise flat, frontal, and static letterforms are adapted. This includes the spaces, surfaces, layers, and structures through which users and readers navigate and manipulate. Ergonomic characteristics play a role here as developers strive to invent ways humans can seamlessly interface with—and enter—the fusion of typographic language and digital technology.

distance

between

our

breath

comes between

sound

Electric Body, part of an ongoing series exploring cyberhuman dancers and virtual spaces, is an interactive dance work utilizing a touch-sensitive floor designed with a Musical Instrument Digital Interface (MIDI). The dancer's movement on the floor triggers sounds and projections of animated cyberhumans who respond to the dancer's improvisations.

This work, in addition to exploring basic issues of interactivity, typography, sound, and improvisation, seeks to engage in a process leading to a collaborative exploration of technologically mediated worlds.

The Dance Typographic

Shy.Grrl.Flux is an interdisciplinary research collective committed to addressing connections between design, women, and culture. Through a broad design and writing practice Shy.Grrl supports, initiates, and encourages both thoughtful response and critical observation.

1. TITLE *Electric Body* · FORMAT Video, Performance · ORIGIN Lisbon, Portugal DATE 1997 · DESIGNER Katie Salen · SOUND/FLOOR DESIGN Russell Pinkston CHOREOGRAPHER Yacov Sharir
2. TITLE *CyberHuman Dance Series: Hollow Ground* · FORMAT Video, Performance · ORIGIN United States · DATE 1996 · DESIGNERS Katie Salen, Nate Pagel, Paulus Thisnadi · COMPOSER Tom Lopez · CHOREOGRAPHY Yacov Sharir
3. TITLE *Shy.Grrl.Flux title sequence* · FORMAT Video · ORIGIN United States DATE 1997 · DESIGNER Katie Salen · COMPANY Shy.Grrl.Flux

2

3

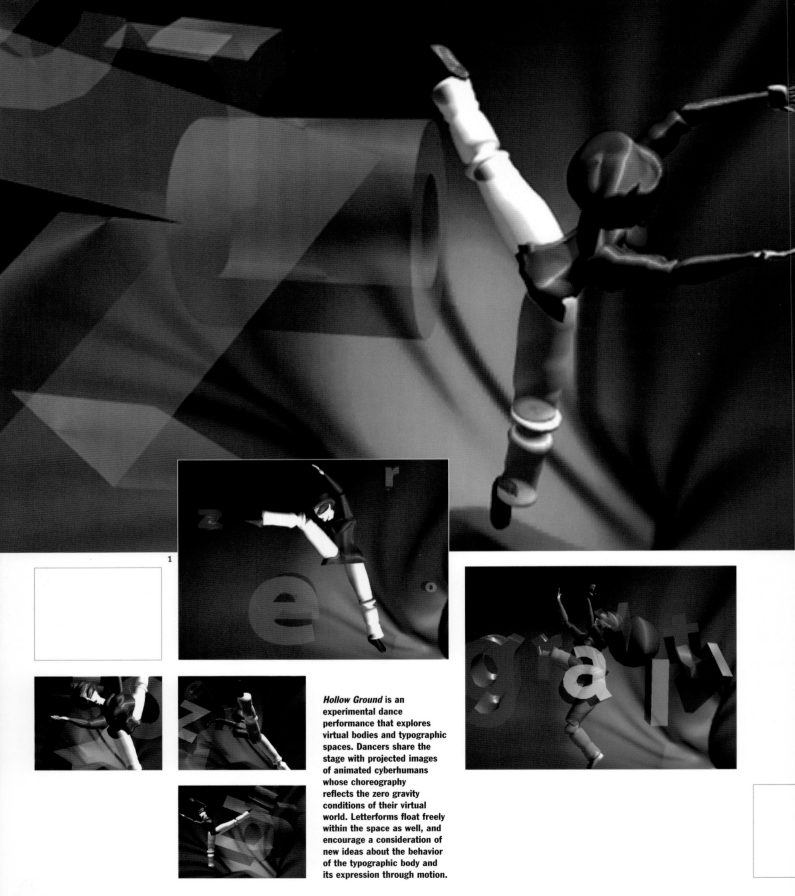

1

Hollow Ground is an experimental dance performance that explores virtual bodies and typographic spaces. Dancers share the stage with projected images of animated cyberhumans whose choreography reflects the zero gravity conditions of their virtual world. Letterforms float freely within the space as well, and encourage a consideration of new ideas about the behavior of the typographic body and its expression through motion.

Exploration and Discovery

Zed is a quarterly publication unique in its exploration of issues specifically related to design as a cultural activity. Its mission is to bridge the gap between designer, student, and educator, while functioning as a vehicle for divergent viewpoints and new voices, especially of young designers and design educators looking for critical forums to publish their work and research.

1. TITLE *CyberHuman Dance Series: Hollow Ground* · FORMAT Video, Performance · ORIGIN United States · DATE 1996 · DESIGNERS Katie Salen, Nate Pagel, Paulus Thisnadi · COMPOSER Tom Lopez · CHOREOGRAPHY Yacov Sharir
2. TITLE *Z 2.2 Real World Design: The Role of the Experimental* · FORMAT Digital Media · ORIGIN United States · PUBLISHER Center for Design Studies, Virginia Commonwealth University · DATE 1995 · DESIGNER Katie Salen · EDITOR Katie Salen

2

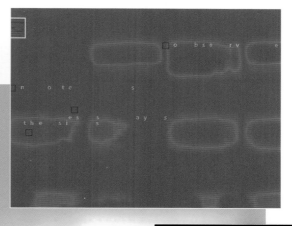

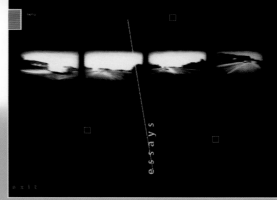

Presented here is the CD-ROM interface for Issue 2 of *Zed*, *Real World Design: The Role of the Experimental*, which explores the function and impact of experimental activity in the field of design.

The visual and navigational structure of the interface emphasizes the role of the experimental as a tool of intervention. The user is presented with the metaphor of speeding through a

landscape, the details of which remain a blur until the user pulls off the road. The computer mouse is the user's eyes—it rolls over various stopping points on the screen, which are hidden from sight

and have no definable information or structure that might pre-determine a particular course of travel. Users of this interface must reassimilate their method of reading as they shift almost seamlessly from the expected to the unfamiliar.

Digital Surrealism

Post Tool Design—a California-based partnership—was formed in 1993 by David Karam and Gigi Biederman. They specialize "in the strange and beautiful" with digital products inhabited by surreal characters, organic objects, three-dimensional letterforms, and other-worldly color palettes.

The Post Tool self-promotion CD-ROM interface, *Post TV*, provides the backdrop for this page. The traveler to this digital land is greeted with a three-dimensional, rotating T and V, set to a calming, mood-influenced soundtrack. The user has the choice of seeing a wide selection of Post Tool projects or of entering an experimental mode which allows the user to re-decorate the interface with various tools. One tool in particular transforms the mouse pointer into a digital paintbrush that spreads colorful spirals and letterforms around the viewing environment.

1

The stills on these pages are from *Cardinal Directions*, a video based on the American Indian notion of the cardinal directions.

2

Centered in this darkened environment is a group of transparent balloon-like objects knotted together, around which three-dimensional letterforms orbit. These letters are arranged in four thought-provoking word groups: sentiment, past, logic, future; object, trait, blanket, corner; claim, level, measure, promise; guide, surface, condition, clear; intended to evoke the significance of the cardinal directions.

1. TITLE *Post TV* self-promotion CD-ROM · FORMAT Digital Media · ORIGIN United States · CLIENT Post Tool Design · DATE 1996–97 · DESIGNERS David Karam, Gigi Biederman · SOUND & CONCEPTUAL DEVELOPMENT Tom Bland · CONTRIBUTORS Margaret Crane, Todd Hido, Terbo Ted · COMPANY Post Tool Design (Entertainment Division)

2. TITLE *Cardinal Directions* · FORMAT Video · ORIGIN United States · CLIENT Post Tool Design · DATE 1997 · DESIGNERS David Karam, Gigi Biederman · SPOT ILLUSTRATION Stella Lai · COMPANY Post Tool Design

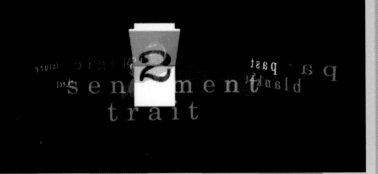

A six-foot-square garden sits in the middle of an otherwise ordinary computer laboratory. Water briskly flows down a series of cascades into a glowing pool. Projected onto the surface of the pool and moving as if they were caught in the water's grasp are a tangle of words. A visitor may reach into the water and block the flow or stir up the words. This activity causes the words to grow, divide and metamorphize into new words that are swallowed by a drain and pumped back to the head of the stream to tumble down again.

The Stream of Consciousness uses a computer interface known as Liquid Haptics. This eliminates the keyboard and mouse and allows the human hand to interact with computer-generated information by directly touching it as it appears on screen or in projection.

Ergonomics

Under the direction of John Maeda, the ACG unites a community of designers and engineers who collectively explore the relationship between visual form and various sensing media to bring the highest standards of graphic design to human–computer interfaces. ACG researchers, Tom White and David Small, are concerned with creating new computer interfaces that are more responsive and easier to manipulate than the traditional, often stubborn, mouse.

TITLE *The Stream of Consciousness: An Interactive Poetic Garden.* ©1997 MIT · FORMAT Mixed Media · ORIGIN United States · DATE 1997 · DEVELOPERS Tom White and David Small · PROJECT DIRECTOR John Maeda · UNIVERSITY Aesthetics and Computation Group, Massachusetts Institute of Technology Media Laboratory · SPONSOR (in part by) the Things That Think and News in the Future Consortia, MIT Media Laboratory · PHOTOGRAPHY page 150. ©1997 Webb Chappell

THESEUS
Go, Philostrate,
Stir up the Athenian youth to merriments.
20 Awake the pert and nimble spirit of mirth.
Turn melancholy forth to funerals
The pale companion is not for our pomp.

[[Exit Philostrate]]
Hippolyta, I wooed thee with my sword,
And won thy love doing thee injuries.
But I will wed thee in another key
With pomp, with triumph, and with revelling.

30[Enter Egeus and his daughter Hermia, and Lysander and Demetrius]

EGEUS
Happy be Theseus, our renowne d Duke.

THESEUS
Thanks, good Egeus. What's the news with thee?

EGEUS
Full of vexation come I, with complaint
40 Against my child, my daughter Hermia.
Stand forth Demetrius. My noble lord,
This man hath my consent to marry her.
Stand forth Lysander. And, my gracious Duke,
This hath bewitched the bosom of my child.
Thou, thou, Lysander, thou hast given her rhymes,
And interchanged love tokens with my child.
Thou hast by moonlight at her window sung
With feigning voice verses of feigning love,
And stol'n the impression of her fantasy
50 With bracelets of thy hair, rings, gauds, conceits,
Knacks, trifles, nosegays, sweetmeats messengers
Of strong prevailment in unhardened youth.
With cunning hast thou filched my daughter's heart,
Turned her obedience which is due to me
To stubborn harshness. And, my gracious Duke,
Be it so she will not here before your grace
Consent to marry with Demetrius,
I beg the ancient privilege of Athens:
As she is mine, I may dispose of her,
60 Which shall be either to this gentleman
Or to her death, according to our law
Immediately provided in that case.

THESEUS
What say you, Hermia? Be advised, fair maid.
To you your father should be as a god,
One that composed your beauties, yea, and one
To whom you are but as a form in wax,
By him imprinted, and within his power
To leave the figure or disfigure it.
70 Demetrius is a worthy gentleman.

HERMIA
So is Lysander.

THESEUS
In himself he is,
But in this kind, wanting your father's voice,
The other must be held the worthier.

HERMIA
... I my father looked but with my eyes.
...ement look.

originally performed between more serious
pieces. The interlude originated in medieval times,
to provide light entertainment between morality or
mystery plays.

... Duke and the Duchess ... play in our interlude

BOTTOM
First, good Peter Quince, say what the play treats
on; then read the names of the actors; and so grow to
a point.

20QUINCE
Marry, our play is
[The Most Lamentable Comedy]
and Most Cruel Death of Pyramus and Thisbe.

BOTTOM
A very good piece of work, I assure you, and a
merry. Now, good Peter Quince, call forth your actors
by the scroll. Masters, spread yourselves.

30QUINCE
Answer as I call you. Nick Bottom, the weaver?

BOTTOM
Ready. Name what part I am for, and proceed.

QUINCE
You, Nick Bottom, are set down for Pyramus.

BOTTOM
40 What is Pyramus? A lover or a tyrant?

QUINCE
A lover, that kills himself most gallant for love.

BOTTOM
That will ask some tears in the true performing
of it. If I do it, let the audience look to their eyes. I will
move stones. I will condole, in some measure. To the
rest. Yet my chief humour is for a tyrant. I could play
50 'erc'les rarely, or a part to tear a cat in, to make all
split.
The raging rocks
And shivering shocks
Shall break the locks
Of prison gates,
And Phibus' car
Shall shine from far
And make and mar
The foolish Fates.
60 This was lofty. Now name the rest of the players.
This is 'erc'les' vein, a tyrant's vein. A lover is more
condoling.

QUINCE
Francis Flute, the bellows-mender?

FLUTE
Here, Peter Quince.

70QUINCE
Flute, you must take Thisbe on you.

FLUTE
What is Thisbe? A wand'ring knight?

QUINCE
It is the lady that Pyramus must love.

FLUTE
80 Nay, faith, let not me play a woman. I have a
beard coming.

QUINCE
That's all one. You shall play it in a mask, and
you may speak as small as you will.

BOTTOM
An I may hide my face, let me play Thisbe too. Thisne, Thisne!
I'll speak in a monstrous little voice: Thisne, Thisne!
90 "Ah Pyramus, my lover dear, thy Thisbe dear and lady
dear."

...INCE
... must play Pyramus; and Flute, you

3D Shakespeare

David Small is an IBM fellow in the Aesthetics & Computation Group (ACG) at the MIT Media Laboratory. Small's research focuses on dynamic typography in three-dimensional landscapes and the design of complex information environments. This pursuit has led Small to construct novel physical interfaces for manipulating virtual objects containing large bodies of text, such as the collection of Shakespeare's plays and an essay by Emmanuel Levinas on the *Talmud*, which contains an intricate web of references to the *Torah*.

TITLE *The Shakespeare Project.* ©1997 MIT · FORMAT Digital Media · ORIGIN United States DATE 1997 · DEVELOPER David Small · PROJECT DIRECTOR John Maeda · UNIVERSITY Aesthetics and Computation Group, Massachusetts Institute of Technology Media Laboratory

In these examples, the footnotes, named because of their location on the page rather than their function, are relocated to be congruent to, and ninety degrees from, the main text to which they refer. In this way, they are unobtrusive, yet conveniently located and easily accessible. Various interfaces were used to allow the reader to position his virtual eye around the text—a moveable stage, which represented the orientation of the text, and a helicopter, which represented a virtual eyepoint.

The display of information on computers does not often fulfill the promise of the computer as a visual information appliance. Here, in this design experiment, a large body of text, such as the complete plays of William Shakespeare, is made visible. The typography is designed to handle display at a variety of scales so that the user can move smoothly between detailed views and overviews of as many as one million words.

Visual filtering techniques are described that aid the analysis of text at a wide range of scales. Also, the use of three-dimensional space to organize complex relationships among different information elements is described. New interaction paradigms are explored that help the navigation of complex, three-dimensional information spaces.

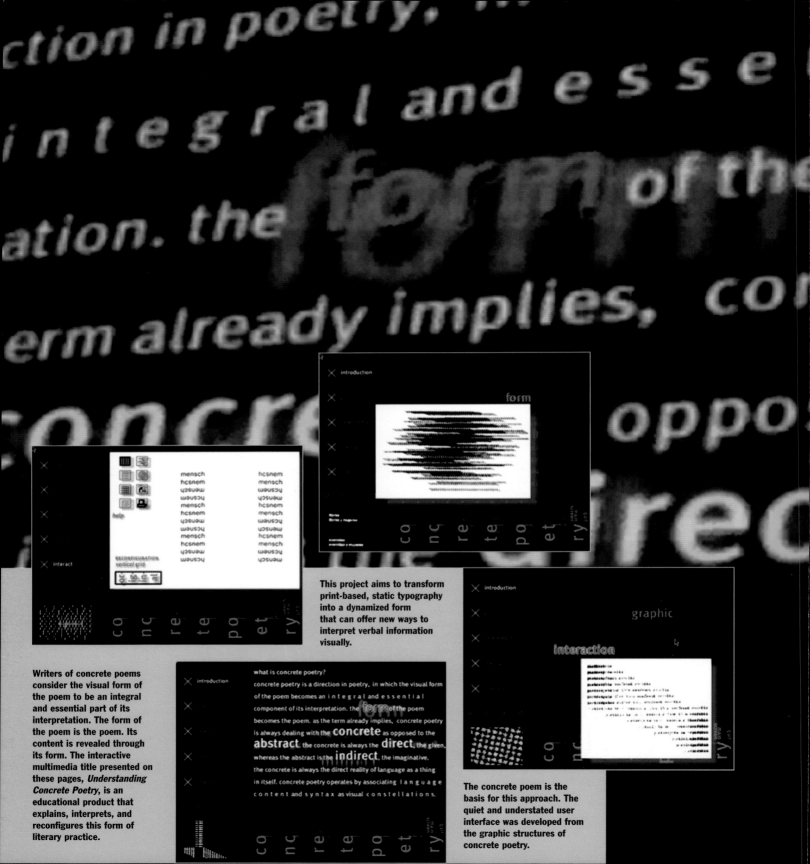

This project aims to transform print-based, static typography into a dynamized form that can offer new ways to interpret verbal information visually.

Writers of concrete poems consider the visual form of the poem to be an integral and essential part of its interpretation. The form of the poem is the poem. Its content is revealed through its form. The interactive multimedia title presented on these pages, *Understanding Concrete Poetry*, is an educational product that explains, interprets, and reconfigures this form of literary practice.

The concrete poem is the basis for this approach. The quiet and understated user interface was developed from the graphic structures of concrete poetry.

From Liquid to Concrete

Thomas Mueller is interested in addressing the transformation of print-based, static typography into what he refers to as *liquid typography:* a dynamized form present in time-based and interactive environments.

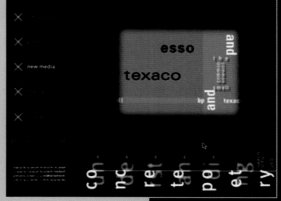

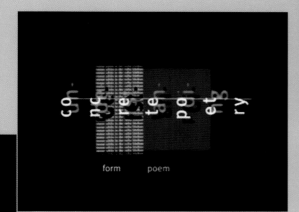

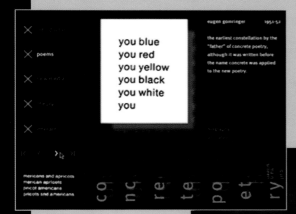

Five different sections provide the user with information about concrete poetry. The sections range from literary theory to dynamic typographic visualizations of the sometimes complex formal structures of concrete poems.

The various tools allow the user to alter the form of a poem temporarily, and even animate the poem.

A temporal-spatial environment replaces buttons and click-menus and allows the user to access the subject matter intuitively. The interface offers a simultaneity of accessing the poetry examples by analytical category or by an emotional approach that is based on visual stimulation.

TITLE *Understanding Concrete Poetry* · FORMAT Digital Media · ORIGIN United States · DATE 1995 · CONCEPT, DESIGN, PROGRAMMING, AUDIO Thomas Mueller · FACULTY ADVISORS April Greiman, Somi Kim, Simon Johnston, Peter Lunenfeld, Florian Brody · UNIVERSITY Art Center College of Design, Pasadena, California

Signifiers and Signifieds

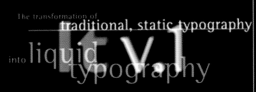

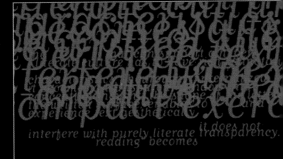

Typographic Behavior

Typographic Signifier

Sequential appearance

Typographic Visualization

Liquid Typography

Typographic Property

Long form

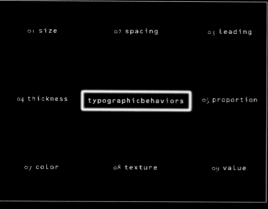

TITLE *Liquid Typography* · FORMAT Digital Media, Video, Print · ORIGIN United States · DATE 1996 · CONCEPT, DESIGN, PROGRAMMING, AUDIO Thomas Mueller · FACULTY ADVISORS April Greiman, Somi Kim, Simon Johnston, Peter Lunenfeld, Fred Fehlau · UNIVERSITY Art Center College of Design, Pasadena, California

This project is a collection of research projects created while Thomas Mueller was a graduate student at the Art Center College of Design in Pasadena, California, and on which he is still working as a post-graduate.

These studies explore the phenomenon of typography in time-based and interactive environments while considering the word-image and the typographic-image as established through traditional, print-based applications.

Experimental Typography Generator, a digital age "Fluxus Concrete Poetry" interactive program, employs a group of simple keyboard commands so that the user can manipulate the size and movement (free or constrained) of black letterforms, while "drawing" with them on a white field. Pressing the space bar allows the user to edit a type string of up to three or four words long; letterforms can be erased as quickly as they are drawn using the delete key. With this simple, ready-made tool kit, an impressive body of experimental type layouts can be generated in a matter of minutes. Little thought or creativity is required, though it may enhance results for some users. In reducing hours, even years of tedious work and groundbreaking experimentation into minutes of Etch-A-Sketch®-like fun, does this program turn much postmodern theory and type design against itself, or carry it to more logical extremes?

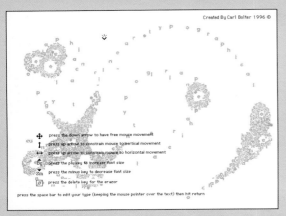

Created By Carl Bolter 1996 ©

Interactive Font Design Companion, a different solution to the same brief, utilizes three-dimensional animation to simulate a hand-held device. This interface allows the viewer to interact directly with the typography and create a typeface by choosing the size, color, and speed of the constantly mutating letterforms.

The opening title sequence for the *Universal Issues* interactive involves the creative use of laser-printed text, a bowl of water, and an overhead projector. The projected simulation of floating letterforms is then captured on video.

3

1

2

Anatomy of a Typeface

(4) Here, students have explored how to communicate information by creating a timeline which contains three levels of information: personal, design, and world history. In this interactive *Personal Timeline*, navigation is accomplished by altering the position of the dates within the interface through the use of the mouse. The three levels of information are organized hierarchically in space: personal information is the largest and closest to the viewer, world history is the smallest and farthest, and design history lies in the middle. Specific information pertaining to each year of the timeline can be accessed by clicking on the date.

(5) The students' brief was to relate typography to the human body by developing *Anatomy of A.* Here the solution is a puzzle/game that is at once playful, nostalgic, educational, and disturbing. After all, what, besides sharing a first letter, do typography and torture have in common? Is this work a promotional piece for Amnesty International, or simply a student's idea of a sick joke, or a novel attempt to relate human anatomy to that of letterforms? This provocative creation raises more questions than answers.

A user must scramble the parts of the uppercase letterform "A", complete with labeled anatomical parts, breaking it up into equal-sized square units within a larger square frame. One square is always left open, another move always possible. Watching the program rapidly and randomly shift pieces in response to a user's commands can be perceived as tortuous when compared with the agonizing amount of effort and relatively slow pace with which an average user attempts to rebuild the letterform. A background image of a torture victim affixed to a makeshift cross, an outstretched body crudely mirroring the "anatomical A", dissolves in and out, periodically replacing the letterform as the user continues working. The user ends up simultaneously helping to re-create the scene of a heinous crime ending in death while attempting to bring an "A" back to life.

1. PROJECT *Experimental Typography Generator* · FORMAT Digital Media · ORIGIN New Zealand · DATE 1996 · INSTRUCTORS Jeff Bellantoni, Shawn McKinney · DESIGNER Carl Bolter · UNIVERSITY Wanganui Polytechnic School of Art and Design
2. PROJECT *Interactive Font Design Companion* · FORMAT Digital Media · ORIGIN New Zealand · DATE 1996 · INSTRUCTORS Jeff Bellantoni, Shawn McKinney · DESIGNER Matt Penrad · UNIVERSITY Wanganui Polytechnic School of Art and Design
3. TITLE *Universal Issues* · FORMAT Digital Media · ORIGIN New Zealand · CLIENT George Krause · DATE 1995 · DESIGNERS Jared Forbes, Taera Crane, Lim Kai Teng · UNIVERSITY Wanganui Polytechnic School of Art and Design
4. PROJECT *Personal Timeline* · FORMAT Digital Media · ORIGIN New Zealand · DATE 1996 · INSTRUCTORS Jeff Bellantoni, Barb Schubring · DESIGNER Tim Fouhy · UNIVERSITY Wanganui Polytechnic School of Art and Design
5. PROJECT *Body Type Puzzle* · FORMAT Digital Media · ORIGIN New Zealand · DATE 1996 · INSTRUCTOR Shawn McKinney · DESIGNER Tim Fouhy · UNIVERSITY Wanganui Polytechnic School of Art and Design

4

5

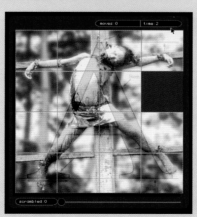
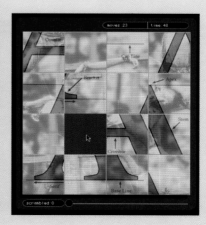

Painting with Letters

After building a strong reputation as a graphic designer in Tokyo, Japan, John Maeda returned to Cambridge, Massachusetts, to become assistant professor and director of the Aesthetics & Computation Group (ACG) at his alma mater, the MIT Media Laboratory. Maeda is also principal of Maeda Studios, which develops advanced design work for digital and paper. Maeda actively seeks to bridge the gap between computational and non-computational expression by designing print-based work which illustrates a sensitivity to the past while embracing the future. He also pushes the envelope of expression with work created solely for the digital medium.

PROJECT Experiment for the 1995 Tokyo Type Director's Club Annual Exhibition · FORMAT Digital
Media · ORIGIN Tokyo, Japan · CLIENT Tokyo Type Director's Club · DATE 1995 · DESIGN &
COMPUTATION John Maeda · COMPANY Maeda Studios

Letters dance around these
frames in response to the
motion of the mouse pointer
in this interactive experiment
for the 1995 Tokyo Type
Director's Club Annual
Exhibition in Tokyo, Japan.

Utilizing Maeda's *concentrics,*
the mouse serves as a real-
time motion-capture device:
the curser is wired to a string
of letters that spell Tokyo
Type Director's Club 95.

Displaying Time

This bi-monthly, interactive calendar series for *Shiseido*, a Japanese cosmetics company based in Tokyo, flirts with the traditional method of visually mapping the notion of time. The user literally enters these calendars with the computer mouse pointer. Numerals representing the days of the month respond to the mouse in a pattern that follows the programmed theme for that month.

(1) January/February 1997
Cosmos is an experiment that visualizes time as an orbital phenomenon.

(2) March/April 1997
Line is an experiment that visualizes time as a linear phenomenon.

(3) May/June 1997
Flora is a celebration of the beauty of spring.

TITLE *Shiseido Java Calendars* · FORMAT Digital Media · ORIGIN Tokyo, Japan · CLIENT Shiseido, Inc. · DATE 1997 · DESIGN & COMPUTATION John Maeda · COMPANY Maeda Studios

(4) July/August 1997
Hanabi captures a summer fireworks spectacle.

(5) September/October 1997
Umi/Aki pays tribute to the brilliance of fall foliage, while reminiscing about a summer day at the ocean.

(6) November/December 1997
Snowflake is an interpretation of the structure of a snowflake.

Dynamic Information

Thomas Noller is a member of the Internet team at the Berlin headquarters of MetaDesign. The team specializes in the online appearance of major German companies such as Audi with the main goal of extending existing corporate guidelines and applying them to the World Wide Web for a consistent look and feel on local and international levels. Noller extends his interest in Internet technologies, investigating issues of interface design and typography as they relate to the limitations of the Web. One pursuit, <typospace>, which is depicted on these pages, is a result of this research.

<typospace>

In only a few years the World Wide Web has grown from a text-based information delivery system, with little more communications ability than e-mail, into a visually emphasized, fully interactive universe. This does not come without growing pains. The ease of delivery and access to a seemingly unlimited supply of information can have an adverse effect on the efficiencies that computer technology promises.

The purpose of Typospace, a website designed and produced by Thomas Noller, is to collect and survey new technological developments and ideas that may be of help in a more dynamic web-browsing experience. Noller refers to this as *Dynamic Information*.

A *Dynamic Information* space is one in which the user has a better understanding of how information is transmitted and received, in which the point and click metaphor is replaced by a more continuous and intuitive means of gathering useful information.

Typospace is a collection
of studies that demonstrate
various enhancements one
can consider when designing,
programming or navigating
a website. The potential
for the synthesis of word
and image in a time-based,
kinetic situation is evident
in this blip-vertisement for
Nike, which asserts: "speak
my language."

Text circumscribes
the website navigator
in this virtual-architectural
environment constructed
with the words of a quotation
from a short story by Jorge
Luis Borges.

TITLE *Typospace* · FORMAT Digital Website · ORIGIN United States
DATE 1996 · DESIGNER Thomas Noller · All material ©1996 Thomas Noller

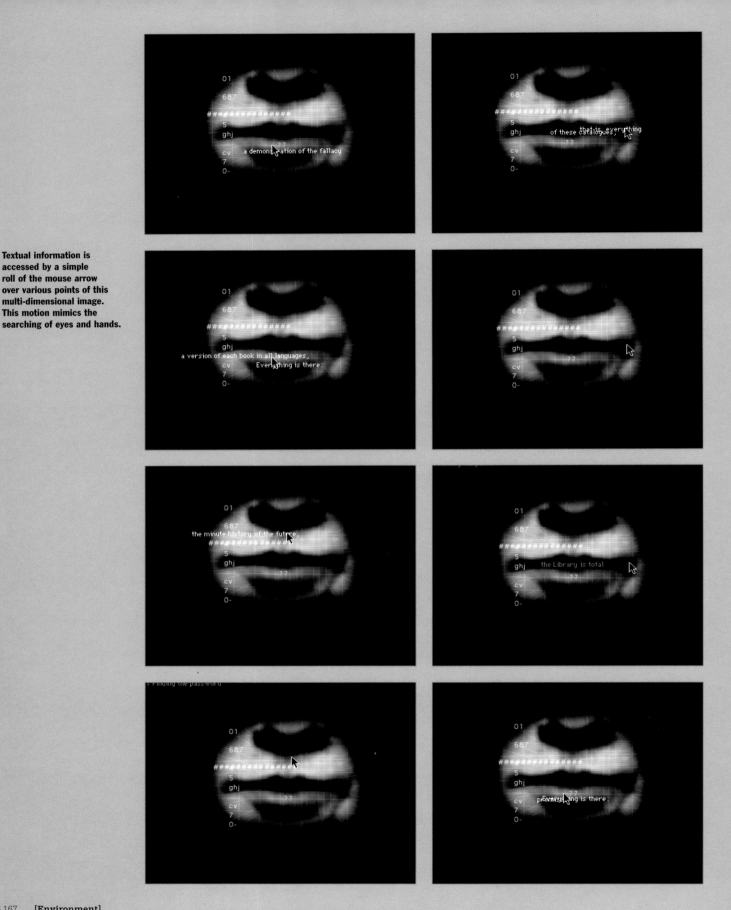

Textual information is accessed by a simple roll of the mouse arrow over various points of this multi-dimensional image. This motion mimics the searching of eyes and hands.

Typospace

TITLE *Typospace* · FORMAT Digital, Website · ORIGIN United States
DATE 1996 · DESIGNER Thomas Noller · All material ©1996 Thomas Noller

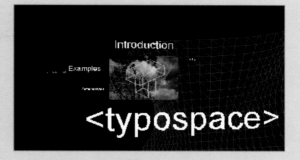

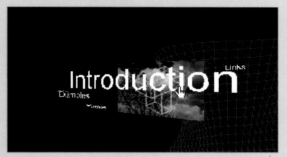

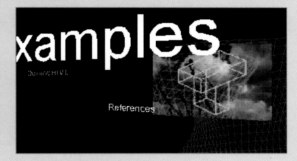

This alternative, three-dimensional representation of the Typospace home page organizes text spatially rather than flat and frontally. The importance of each topic is represented by its position in space, with the words activated as links to other information areas.

A three-dimensional letter T rotates 360 degrees in response to the motion of the mouse arrow in this demonstration of letterforms taking on a monumental, space-occupying quality.

XL HISTORY

92

93

to order call toll free
800 XLARGE1
X-girl spring 97

to order call toll free
800 XLARGE1
X-large spring 97

X-Large is a clothing company with an online catalogue. This website displays a kinetic synthesis of type and image to present its product line. The interface is buttonless, and uses roll-over mechanisms to activate the various pages.

Online Experiments

Michael Worthington teaches in the Graphic Design Program of the Art School at the California Institute of the Arts, where he is also Director of the Macintosh Lab. With his company Worthington Design, he makes typography and design for both print and screen.

MACHINE VISIONS:

towards a poetics of

ARTIFICIAL INTELLIGENCE

I II III IV V VI VII

written by Matthew G. Kirschenbaum

designed by Worthington Design, Los Angeles

The *Electronic Book Review* is an online magazine that features guest editors who choose the content for each issue. The feature presented here is an essay on new media and typography, by Matt Kirschenbaum.

1. TITLE *X-Large Clothing Company Website* · FORMAT Digital Media · ORIGIN United States · CLIENT X-Large Clothing Company · DATE 1997 · DESIGNER Michael Worthington · COMPANY Worthington Design
2. TITLE *Electronic Book Review* · FORMAT Digital Media · ORIGIN United States · CLIENT Anne Burdick · DATE 1997 · DESIGNER Michael Worthington · COMPANY Worthington Design

Video Projection

Digital Experience is a computer lab located at the Getty Information Center. Designed by the architect Michael Maltzan, this facility integrates typographic wall graphics and video projection screens.

The one-minute movie loop presented here is an introduction to Digital Experience that appears on both the video projection and computer screens.

Personal E-mail.animation is a personal electronic mail device designed to push beyond the static nature of the e-moticon: ":-)", so limited and so uninspiringly used in the generic e-mail format of today.

The device is conceived to infuse the user's message with more authentic personalities and expressions. The device interprets the sender's handwriting, chooses a typeface, and conveys his/her emotion and personality.

The LCD screen is, on the sender's end, a digital notepad for handwriting the e-mail, while, on the receiver's end, it functions as a digitally translated real-time record of the sender's thoughts. These thoughts appear on the screen of the receiver in the same tempo in which the letter was generated, and are animated by

a digital interpolation of emphasis directed by the sender's handwriting. For example, when the sender underlines something three times, the device translates typographically to blink three times; when pressing hard, the text appears more bold.

1. TITLE *Digital Experience* · FORMAT Video
ORIGIN United States · CLIENT Getty Information
Center · DATE 1997 · DESIGNER Michael Worthington
COMPANY Worthington Design
2. TITLE *Personal E-mail Animation* · FORMAT Digital
Media · ORIGIN United States · DATE 1997
INTERFACE DESIGN Kathryn Marsan · PRODUCT
DESIGN Carla Diana · UNIVERSITY Cranbrook
Academy of Art

Personalized E-mail

After receiving her graduate degree from Cranbrook
Academy of Art in 1998, Kathryn Marsan immersed
herself in New York City on a quest to transform
electronic mail into a visually expressive communications
vehicle.

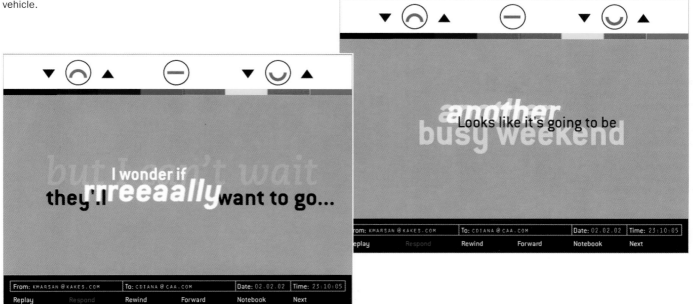

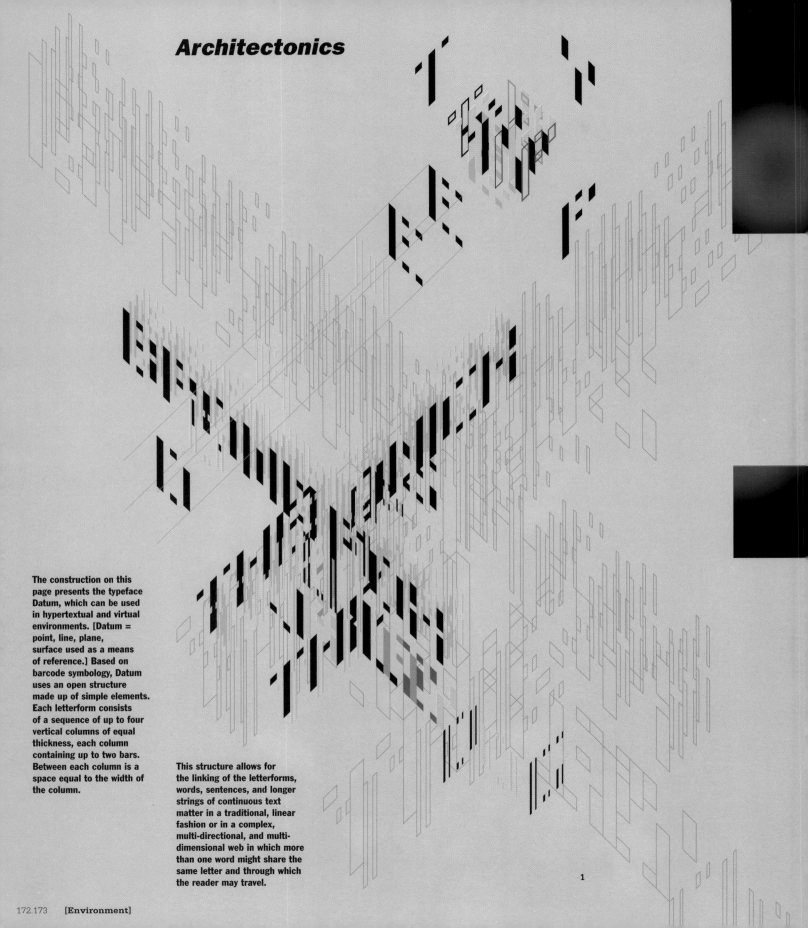

Architectonics

The construction on this page presents the typeface Datum, which can be used in hypertextual and virtual environments. [Datum = point, line, plane, surface used as a means of reference.] Based on barcode symbology, Datum uses an open structure made up of simple elements. Each letterform consists of a sequence of up to four vertical columns of equal thickness, each column containing up to two bars. Between each column is a space equal to the width of the column.

This structure allows for the linking of the letterforms, words, sentences, and longer strings of continuous text matter in a traditional, linear fashion or in a complex, multi-directional, and multi-dimensional web in which more than one word might share the same letter and through which the reader may travel.

1

1. TITLE *Datum*™ · FORMAT Typeface · ORIGIN United States
DATE 1995 · DESIGNER Matt Woolman/-ization ©1995
2. TITLE *Hypertypography: Dimensionality, Joinery, Kinetics*
FORMAT Digital Media · ORIGIN United States · DATE 1995
DESIGNER Matt Woolman/-ization

if not me, it is me
if it is me, it is not mine
if it is not mine it is not me
if it is not me, it is me
if it is me
 it is me not me

if it is not mine
 it is me
if it is me, it is mine
 if it is mine
 it is not me
therefore if it is not me
 it is mine
 mine is mine it is mine

one may
Before one goes
through
the gate
here is a

through

These projects are based
on the classic memory game.
The rules are simple but the
process of play exercises
the mind in an infinite number
of ways. The memory game
allows players to make
connections and guide the
outcome, based on visual
clues. The game does not
have a specific beginning,
middle or end.

The examples on this page
use a computer mouse as
both the hands and eyes of
the player to scan a digital
environment. As the mouse
moves over a certain area
a visual action results.
The player is encouraged
to explore all points of
this environment in order
to assemble all the pieces
of a visual/verbal puzzle that
incorporates typographic
form with light and space.

Language Games

An Urban Alphabet

TITLE *Urban Alphabet* · FORMAT Photography · ORIGIN United States DATE Fall 1997 · INSTRUCTOR Chuck Scalin · UNIVERSITY Virginia Commonwealth University, Richmond · PHOTOGRAPHY [sophomore visual fundamentals] **A** Tsega Dinka; **B** Greg Cross; **C** Erik Lindstrom; **D** Tiffany Allison; **E** Eddie Wilson; **F & G** Pete Foster; **H** Angeline Robertson; **I** Geraint Krumpe; **J** Greg Cross; **K** Phil McKenney; **L** Angeline Robertson; **M** Tiffany Allison; **N** Erik Lindstrom; **O** Tiffany Allison; **P** Angeline Robertson; **Q** Greg Cross; **R** Erik Lindstrom; **S & T** Pete Foster; **U** Greg Cross; **V & W** Eddie Wilson; **X** Greg Cross; **Y** Angeline Robertson; **Z** Ernest Almazan

UNTITLED/IMAGEVSTEXT
by MORRIX

This tin, wire, enamel, and found object piece is a response to the contemporary battle between image and text. The text here is appropriated from a textual panel under a painting in the Cloisters, New York City. As cultures become image saturated, it is the text that demonstrates the intellectual property rights of the educated elite. Dense text can be rendered, or constructed, or wired together piece by piece. The block letters echo an Art Deco typeface slightly incongruous with the found antique frame which alludes to old money and presumed power. The composition forms a bull's eye and the letters cast a drop shadow on the wall on which the piece hangs. The suspended letters move and flutter in response to the motions of passers by. Aware that most people only look at paintings for ten to fifteen seconds, one cannot avoid the pleasure of watching people take quite some time to read this piece.

MORRIX was born in Detroit, Michigan and received his MFA/Sculpture from the School of the Boston Museum of Fine Arts in 1990. He currently makes art in Jamaica Plain, Massachusetts.

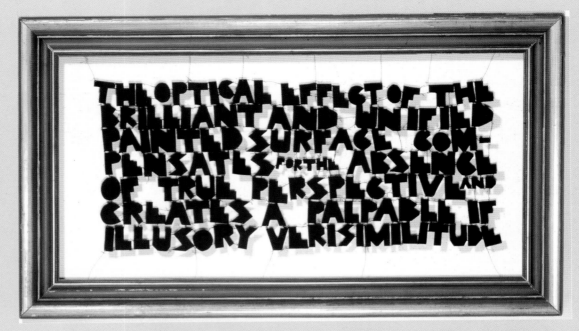

ACKNOWLEDGMENTS

The authors wish to give special thanks to the following for consultation, generous assistance and contributions in the making of this book: every designer and artist who took time out of their busy schedules to collect and send us their work; The University of Connecticut Research Foundation; The Department of Art and Art History, The University of Connecticut; The Department of Communication Arts & Design and Center for Design Studies, Virginia Commonwealth University; John DeMao; Jerry Bates & The Graphics Lab Staff; our very own Joe DiMicelli; Bob Kaputof; devoted interns: San Van, Gem Veranga, Mark Zenone; Paul Zehrer and Jimmy Ray, all at Virginia Commonwealth University; Wendy Wenzell, Brad Roberts & The Family of Saul Bass; Pablo Ferro and Joy Moore; The Title House, Los Angeles; Kelly Galligan & R/Greenberg Associates; Donald Moffett & Bureau; Yvonne Chalk & Tony Kaye & Partners, London; Cathie Hay & Lambie Nairn@The Brand Union; Chris Pullman & WGBH Boston; Erik van Blokland & LettError; Gregory Vines & the Basle School of Design; Kristin Hughes; Ham; and, most definitely, our friends, teachers, and colleagues who make their living pushing letters around.

-IZATION is JEFF BELLANTONI and MATT WOOLMAN

Jeff Bellantoni is Assistant Professor of Visual Communication: Design at The University of Connecticut, where he teaches graphic design, interactive media, and time-based typography and design. He has previously held academic appointments at Wanganui Polytechnic School of Art and Design in New Zealand and Virginia Commonwealth University.

Matt Woolman is Assistant Professor of Communication Design at Virginia Commonwealth University where he teaches typography, publication design, and design process. Matt is the author of *A Type Detective Story: The Crime Scene* (Switzerland: RotoVision, SA, 1997).

Founded in 1995 by Jeff and Matt, -Ization is a communication design and media group that specializes in the process of doing and making. Inquiries: studio@ization.com

BOOK DESIGN & PRODUCTION: -IZATION · TYPEFACES: Serifa & Franklin Gothic families
IMAGE CREDITS: cover, end papers, p. 002, pp. 004–005, pp. 006–009, 036–037, 078–079, 106–107, 142–143, 176 ©1998 Jeff Bellantoni · ADDITIONAL CREDITS: collaboration on cover design concept: Kristin Hughes; folio flip book design: Kristin Hughes; pp. 114–115, ©1998 Ned Drew, The Design Consortium; text on pp. 158–159 ©Shawn McKinney.

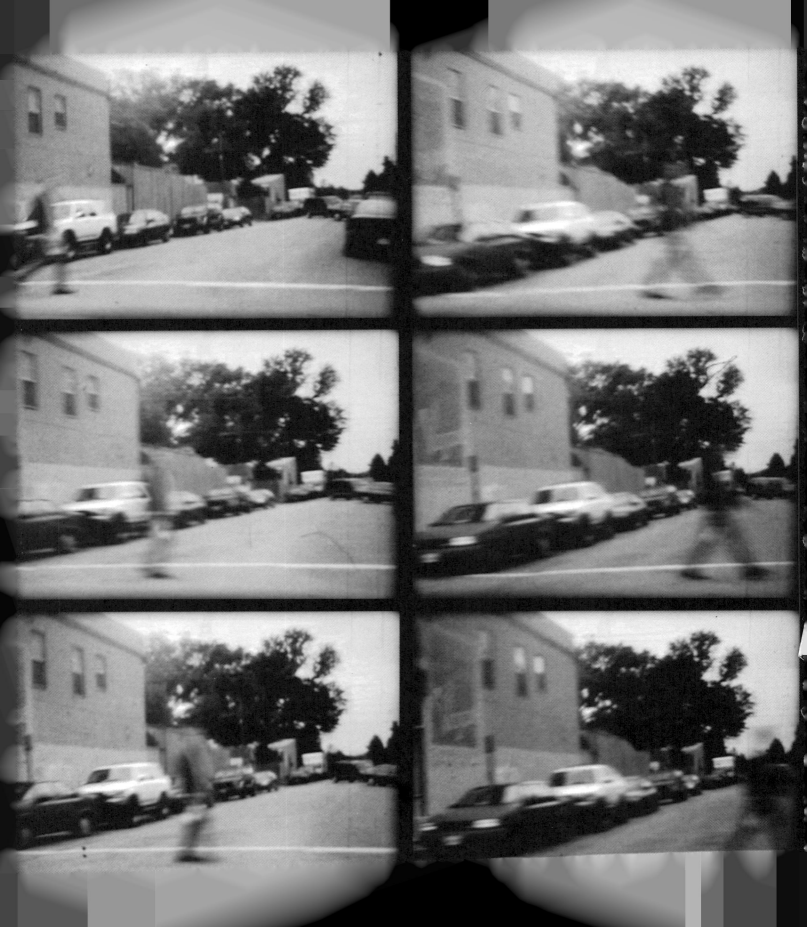